FANTASY UNDERGROUND

How to Draw

WIZARDS

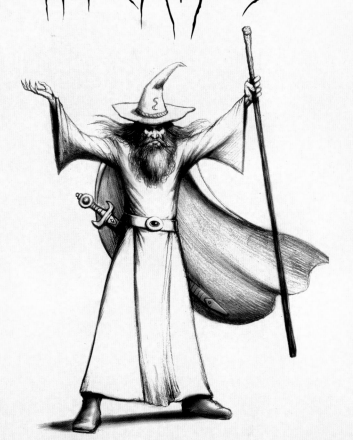

by John Rheaume

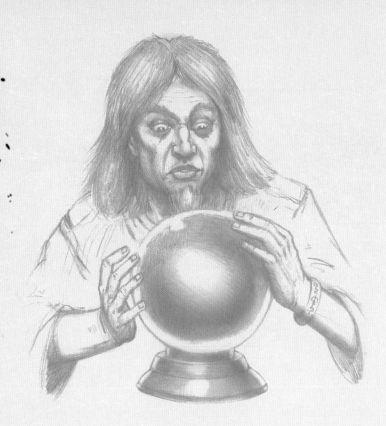

Project Manager and Editor: Meghan O'Dell

Designer: Shelley Baugh

Production Design: Debbie Aiken

Production Management: Lawrence Marquez and Nicole Szawlowski

Printed in China.

1 3 5 7 9 10 8 6 4 2

FANTASY UNDERGROUND
How to Draw
WIZARDS

by John Rheaume

www.walterfoster.com

Walter Foster Publishing, Inc.
3 Wrigley, Suite A
Irvine, CA 92618

Contents

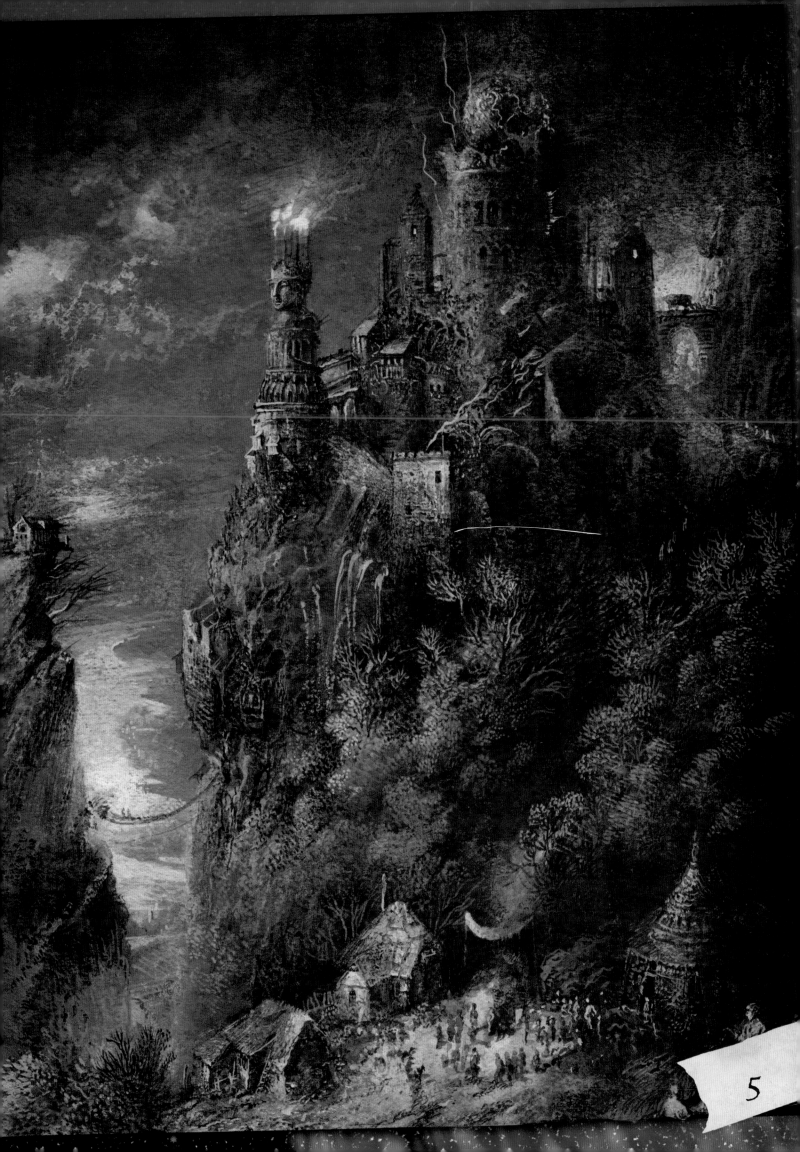

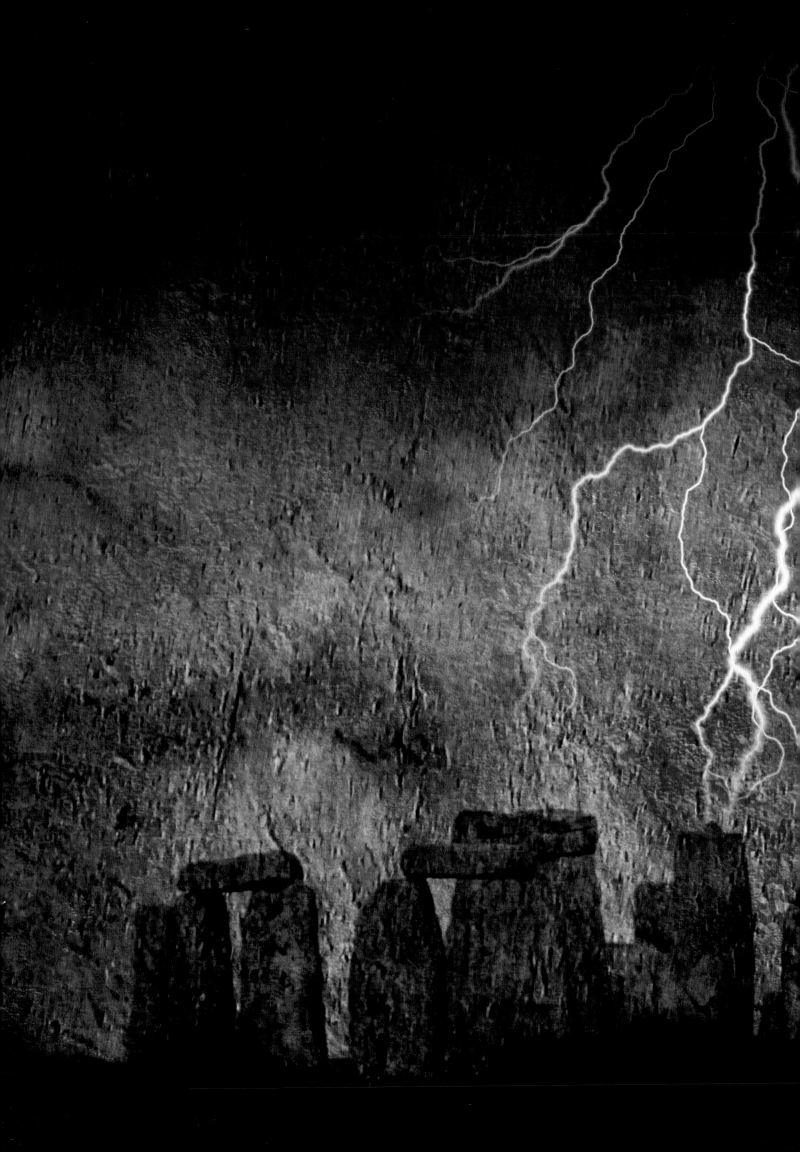

Chapter 1:
Introduction to Drawing
& Painting Wizards

We are all wizards of a kind, each with a different assortment of gifts and powers. If you picked up this book, it would be a safe bet that your gift lies in the realm of artistry.

There are many parallels between the path of the wizard and the path of the artist. Both seek to peek beneath the veil that separates the known from the unknown and to make the unconscious conscious. Many seek out teachers and masters from whom they can learn secrets and tricks. But what really binds them is the desire to create new worlds and to get a glimpse into realms more mysterious than our own.

It is believed that the first wizards (or magi) came from ancient kingdoms of Persia. Revered as high priests of knowledge and learning, they watched the stars, studied the elements, prophesied, and counseled kings. As the eastern empires declined in influence, the magi made their way westward to found the earliest European occult traditions that flourished during the Middle Ages. Soldiers returning from the crusades brought back even more arcane knowledge.

I believe, however, that the first wizards existed before the Persians and recorded time. Wizards in their earliest incarnation (shamans) were the first real artists. It was their job to make sense of things in a dangerous universe. Deep within the dank caves of Lascaux, France, they rendered under a sputtering torch the first cave paintings known to man. It was their way of expressing the mind and spirit of the tribe. The profound skill and expressiveness of these incredible paintings cannot be denied and still astound us today. It is believed that they were painted to ensure success in the hunt. Such was their faith in the power of art.

Later wizards have left us quite an assortment of occult and arcane imagery to explore, ponder, and draw upon: astrological symbols and archetypes, mystical diagrams, Tarot cards, illuminated scrolls, hieroglyphics, wildly illustrated bestiaries, and spell books filled with the portraits of demons and angels who had come to pose.

Wizards can be separated into three distinct groups. The first type of wizard practices white magic. His power comes form a divine source and enlists the aid of God, angels, and the positive energy of nature. The second type practices black magic. His power is derived from a dark, evil source and enlists the aid of Lucifer, a host of demons, and the tortured spirits of the dead. The third type practices both, acting as a mystical double agent.

Both the artist and the wizard must possess knowledge in a variety of skills and disciplines, not just occult magic. You must be a historian, knowledgeable of olden times, clothes, and architecture. You must be familiar with ancient cultures, religion, mythology, demonology, and folklore. Start stocking your library now—you're going to need it.

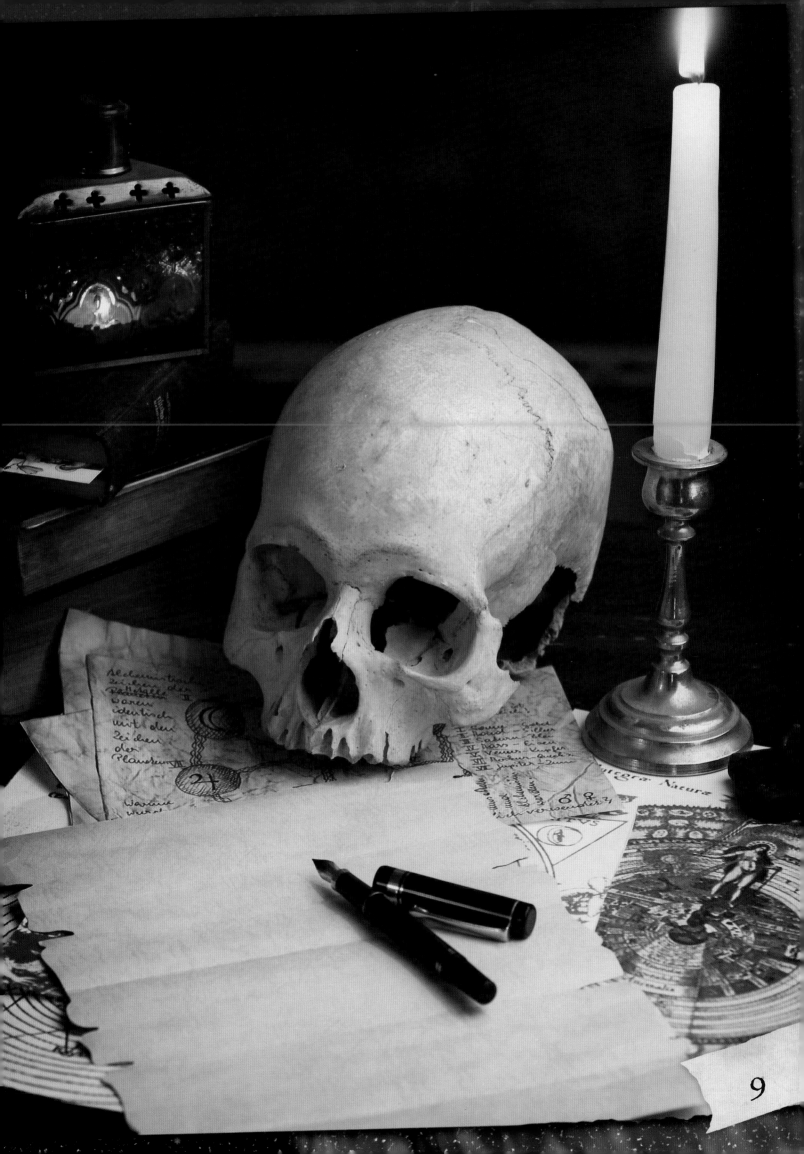

9

In this particular tome, I wanted to go beyond the stereotype of the kindly old wizard with a gray beard, pointy hat, and long robe who brandishes a magic wand. Although these are all part and parcel of the wizardly image, there is so much more to envision, draw, and paint, especially when it comes to a wizard's female counterpart.

As you embark on this journey, remember to take the time to find your own style, as imitation will only take you so far. As your skill develops, you will find imagery and symbols that are your own. You will tell your own story, find your own style, and place your own unique and indelible stamp upon the world.

Within us, deep inside our hearts, exists a mist-enshrouded Avalon of dreams, an island of inspiration we can visit whenever we need to. A giant oak tree, ancient when the world was young, sits majestically at the center. Beneath its swaying boughs stands a beautiful woman, a beguiling enchantress—your own personal muse. Slung over her shoulder is a bag filled with powerful magic. She's been holding it for you since time began, waiting for you to make yourself a vehicle worthy of the gifts she has to offer. All she asks in return is for you to be true to yourself.

Body Types

The human form falls into three main types with infinite varieties among them, and a wizard can be any one of them. We don't want to repeat the generic pattern of the skinny old wizard when there are so many options available to us. Let's start with the basics of developing a character. What kind of body does your character have: the mesomorph (muscular), the endomorph (stocky), or the ectomorph (slender)?

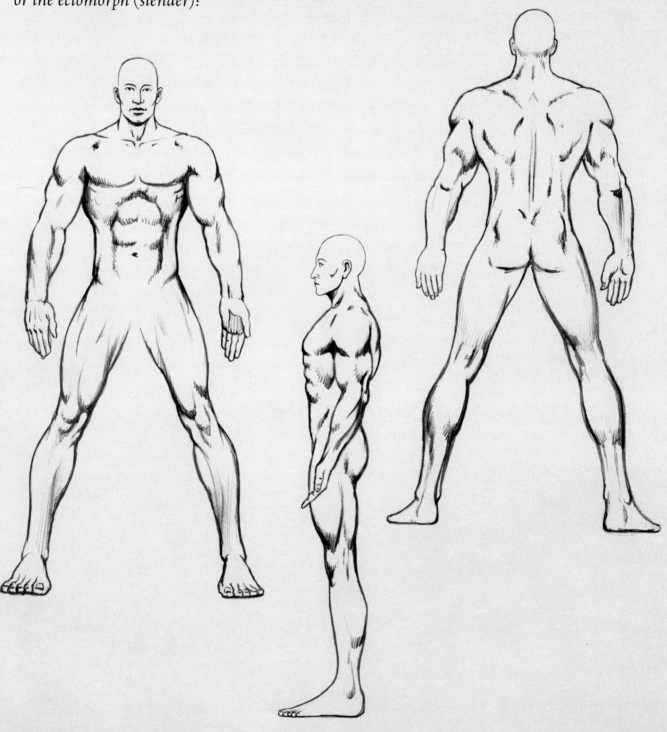

Mesomorph The main characteristic of this heroic type is strong muscular development, especially in the upper body. This also includes a thick neck and strong jawline. Make sure the shoulders are always broader than the waist. If the legs and waist are too thick, it starts moving into the stocky body type. Sometimes the waist can be narrow, and at other times it can be a little wider.

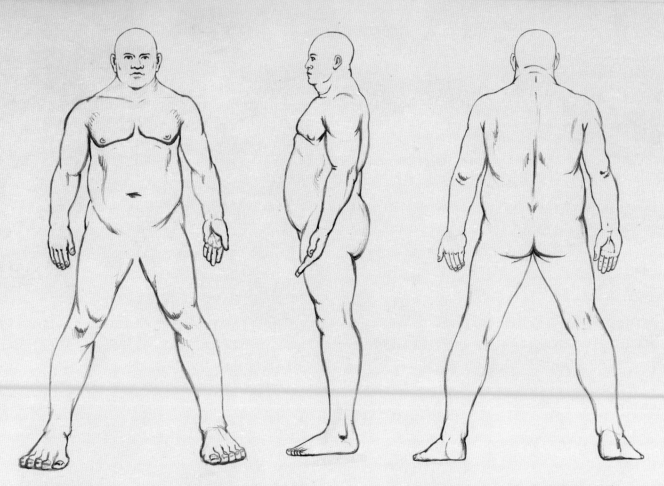

Endomorph The characteristics of this body type are a heavy layer of body fat, rounded shoulders, a big belly, and a thick neck with several chins. There are two main types of endomorphs. One type is pure flab with almost no muscle tone. The other has solid muscle underneath the flab, which provides a sturdy, powerful look.

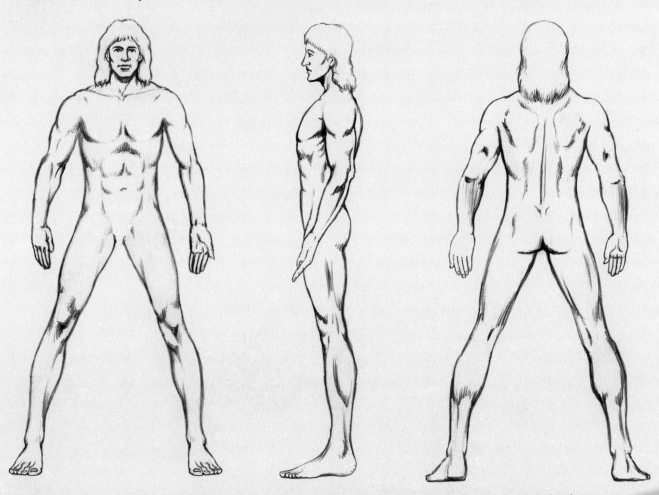

Ectomorph This body type is the most slender and evenly proportioned, with narrow hips and shoulders. The neck tends to be longer and slimmer and the facial features more delicate and refined. Attractive fantasy females have this body type with wider hips, a smaller waist, and trimmer arms and legs.

Character Design Tips

What Works & What Doesn't

Do you ever wonder why some characters work and others don't? If they don't work, it's often because the illustrator simply didn't do his or her homework. If you're going to create a wizard, you need to first study magic and history, as well as what other fantasy artists have done before you.

Who's Your Audience?

Before you create any character, ask yourself whether this character is for kids, adults, young adults, or toddlers. Each group has its own specific parameters. There's a big difference between a Smurf and Gandalf in complexity, shapes, color, and maturity.

Exaggerate, Exaggerate, Exaggerate

The worst thing your character can be called is bland, unless that's what you're going for. Always exaggerate your character's main qualities so his or her personality is clear to the viewer. Ambiguity is not a positive trait in character design.

Be Unique

Whether you're creating a wizard or a gnome, your character needs to have a unique look that separates him or her from the hundreds of similar creations out there. In the beginning we copy, but in the end we should have our own unique style that distinguishes us from the herd.

There's No Such Thing as Too Much Drawing

Draw, draw, draw; then draw some more. You can never draw too many roughs or sketches. You should be filling up one sketchbook per month, stuffed to the brim with ideas and characters. All ideas start as a doodle on scratch paper. Caffeine also helps.

Line Work

The character and the lines that describe his or her shape and shading are inseparable. Thick, soft, even lines usually suggest friendly, cute characters. Scratchy, sharp, heavily textured lines suggest a more unpredictable personality.

Experiment with Angles

A character may look quite different from one angle to another. A long neck, a beer belly, and a hooked nose are only obvious from a side view. Use front, side, and three-quarter views to maximize all the different aspects of your design.

Express Emotion

Showing a character's emotion is what brings him or her alive. One of the most crucial skills you can learn is how to reveal expression. The range and subtleties of human emotion and facial expressions are endless. Always ask yourself, "What is my character feeling right now?"

Tell a Story

What is your character's name? Where did he come from? What are his dreams? Where is he going? What is he scared of? Whom does he love? What is his strength? What is his weakness? What are his flaws? What are his virtues? You get the idea.

Jack Be Quick

Try this exercise: Time yourself with a stopwatch and draw quick gestures of characters in two minutes or less. You'll be amazed at what you can come up with when you don't have time to over-think it.

Environments

What kind of world does the character inhabit? Is it snowy and cold, hot and dry, or wet and rainy? Is it dangerous or peaceful, rich or poor, urban or country? Obviously this affects how the character dresses and interacts with his environment. Environment is one of the key aspects of design and is often overlooked.

Be Specific

This is the most important. Your creations must possess a unique quality all their own. The first sketch is usually the worst and least interesting because it typically looks like what's already been done. The more generic the characters are, the more boring they are, and boring equals death.

Body Type Examples

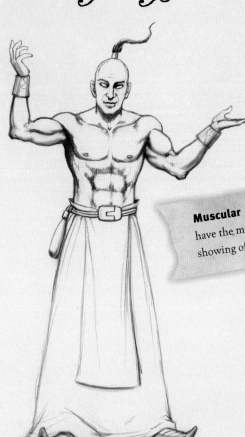

Muscular Here we have the muscular type showing off his abs.

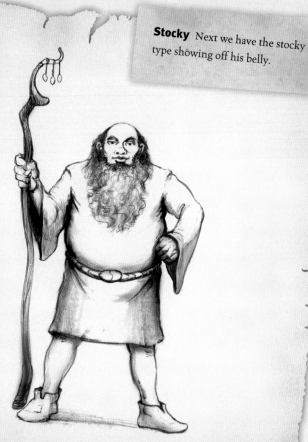

Stocky Next we have the stocky type showing off his belly.

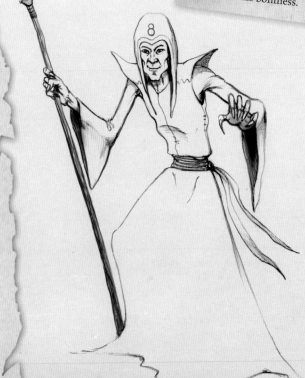

Bony This is the skinny wizard, similar to Saruman from *The Lord of the Rings*. Notice how his limbs are elongated to accentuate his boniness.

Slim This is your typical slim body; the kind of magi that would appear on *American Idol for Wizards*, if such a show existed.

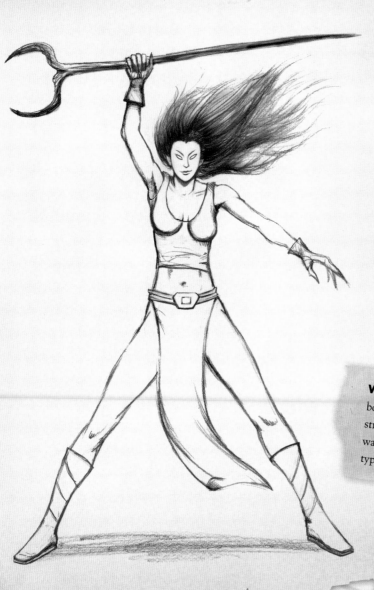

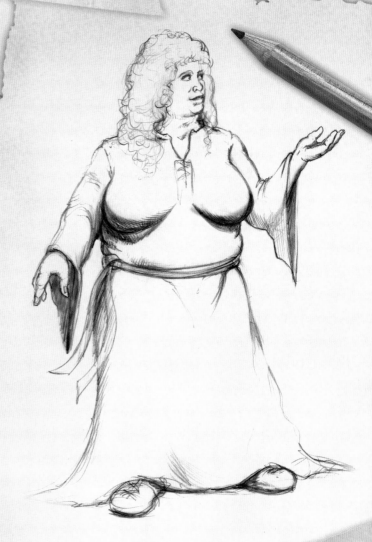

Varying Shapes The types of body shapes are endless. Just sit on a street corner sometime and people-watch. You'll rarely see two body types that are exactly the same.

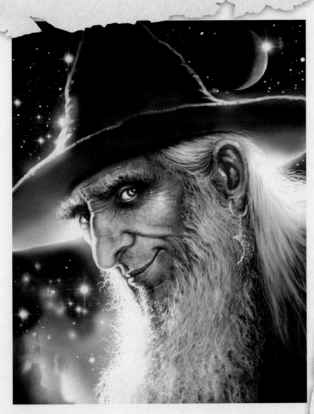

17

Wizard Faces

The human face is capable of creating an infinite number of expressions. It's a subject worthy of a book all by itself. A good test is to draw a face with a certain expression and ask someone which one they think it is. You'll be shocked at how often their answer isn't what you had in mind. Most comic book illustrators I know keep a mirror next to their drawing desk so they can use their own faces for reference. Feeling the emotion in your own facial muscles is very helpful. Drawing expressions in all their wide ranges and subtleties takes many years to master. They say the eyes are the window of the soul, yet the most common mistake beginning artists make is overly contorting the mouth and eyebrows but leaving the eyes too static.

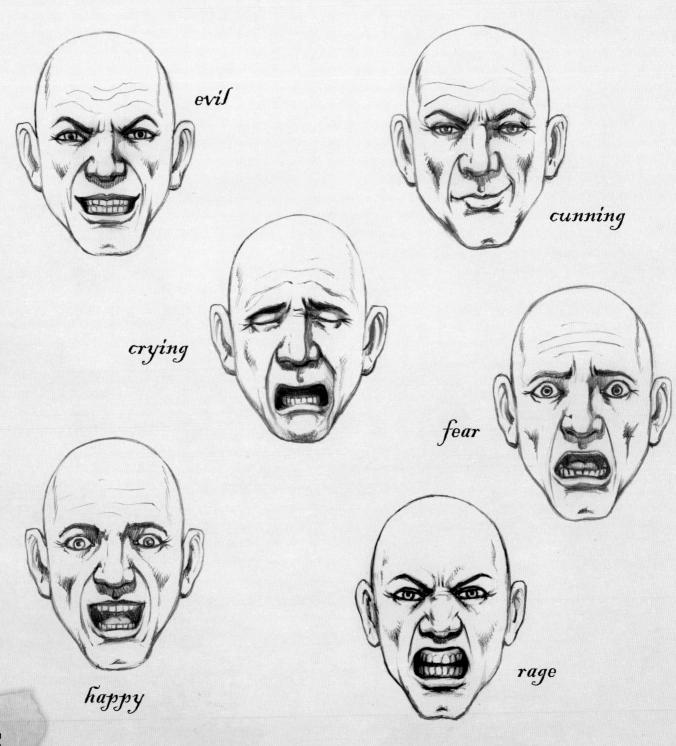

evil

cunning

crying

fear

happy

rage

18

Here's a wide selection of faces for you to peruse. Take time to think about all the different kinds of faces there are to draw. Like expressions, they are infinite. No two are exactly alike. One of the traps I've seen young artists get into is the bad habit of drawing similar faces over and over because it's easy, familiar, and comfortable. Always make the effort and push yourself to do something different and challenging. The sign of a seasoned artist is that you can draw anything well.

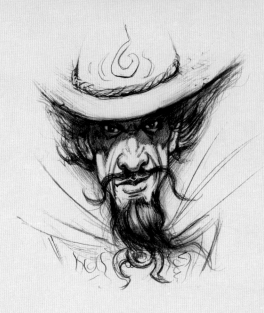

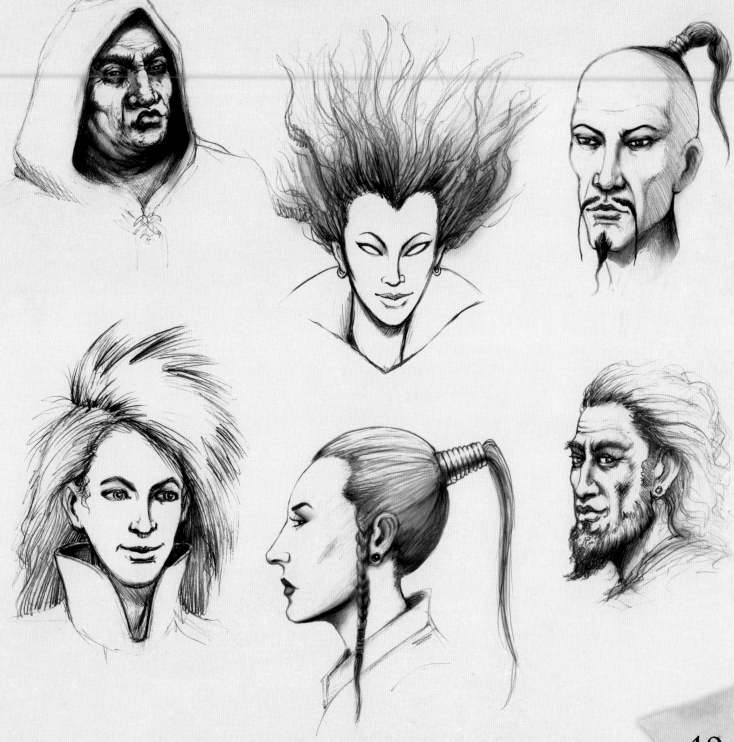

Chapter 2:
Introduction to
Drawing Wizards

The foundation of all visual art is drawing, which is essentially using graphite to render light and shadow and all the varying shades (or values) in between. Before you can create a successful drawing, you must understand values. Keep in mind that for most drawings, values lie mostly in the middle range, and the darker values and highlights usually make up less than 10 percent of the drawing. A good exercise is looking at any drawing or painting and discerning where the percentages of values are.

If you're a serious artist, drawing should be one of your main occupations. The dedicated student should be filling up a sketchbook every month or two. It's always fun to go back and look at your old sketchbooks so you can see how far you've come.

In the same way that a guitarist practices every day without fail until his or her fingertips feel like they're about to fall off, so should the artist continually work away with his or her trusty pencil.

One of the best things about sketching is that you never know where a squiggle or line will lead. Many of the finest works of art started as a doodle in some artist's sketchbook. This is where dreams are given form and life. In countless ways, a pencil and a scrap of paper are perhaps the greatest tools created by man.

Drawing Materials

The wonderful thing about drawing is that all you really need are a pencil and a piece of paper. The beginnings of many outstanding projects were first drawn on a napkin. Interestingly, the most popular pencil just happens to be the standard HB pencil from your school days. It's the one I've always been the most comfortable with, like an old friend. Harder leads are good for tight detail work and straight lines, but HB and the softer leads lend themselves to a wider range of values.

As your skill with a pencil grows you'll gravitate to a narrower range of favorite pencils. You'll rely more on a soft touch and tight control to get the values and lines you want. One of the advantages of drawing is its portability. All you have to do is pick up a sketchpad and your trusty pencil, and you're ready to go.

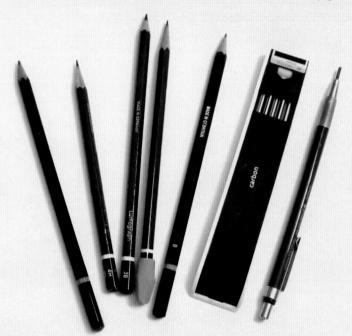

Pencils Drawing would be nearly impossible without pencils. A wide variety is available, but you only really need a certain range. I work with 2H to H pencils (harder leads) for a lighter line, and I use B, HB, and 2B pencils (softer leads) for all the darker areas. Mechanical pencils are fine too, but the key to a good pencil is in how you sharpen the lead.

Indelible Markers Fine-tipped indelible (or permanent) markers are the perfect tools for doing quick sketches and roughing out ideas. For those interested in working in entertainment design, these are some of your main tools.

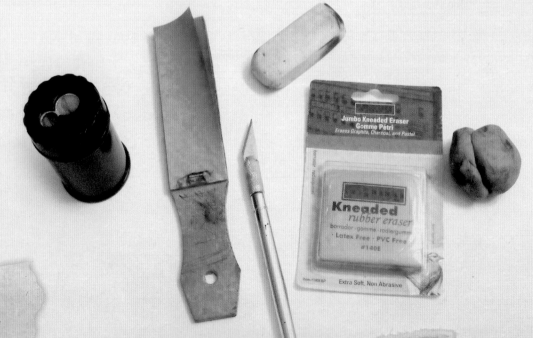

◄ **Sharpeners and Erasers** I often use a small hand sharpener to sharpen my pencils, but I'll also often use a utility knife and sandpaper either to sharpen the lead to a fine point or to angle the lead so I can vary the line width as I draw. I use kneaded erasers most of the time. Sometimes I'll cut a harder plastic eraser at an angle with the utility knife and use it to erase, leaving a sharp edge.

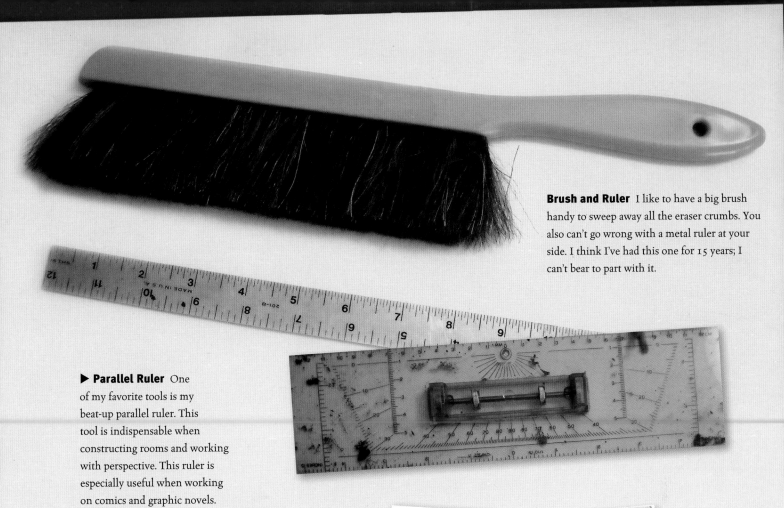

Brush and Ruler I like to have a big brush handy to sweep away all the eraser crumbs. You also can't go wrong with a metal ruler at your side. I think I've had this one for 15 years; I can't bear to part with it.

▶ **Parallel Ruler** One of my favorite tools is my beat-up parallel ruler. This tool is indispensable when constructing rooms and working with perspective. This ruler is especially useful when working on comics and graphic novels.

▶ **Paper** Besides a good sketchpad, my favorite drawing tool is a pad of tracing paper. I almost always create a drawing and then use tracing paper to keep refining the drawing over and over until I get what I want. I also recommend having a stack of plain copy paper nearby for doodling.

25 lb
40 gsm

Transparent, smooth paper ideal for sketches, drawings and overlays with pencil or pen

50
sheets / feuilles / hojas

11x14
27.9 x 35.5 cm

MOST TRANSLUCENT TRACING AVAILABLE

Buy any **2** Canson® pads & get
$2
mail-in rebate
SEE REVERSE FOR DETAILS

Tracing
Calque | Calco

Drawing Standard Wizards

A wizard is a many-faceted character: soothsayer, mystic, seer, magician, alchemist, philosopher, enchanter, and shaman. A wizard also inhabits a multitude of worlds. He sees beyond the limited vision of ordinary men and women, and few ever truly understand him.

The term "wizard" comes from the ancient Anglo-Saxon word "wysard," meaning "wise one." Despite being an integral part of society, wizards were seen as outsiders to be respected and feared. Wherever a wizard traveled, magic was soon to follow. And wherever there was magic, trouble and strange happenings lurked around the corner.

The standard wizard featured in this project is a commanding yet humble sage. The power and praises of this world do not tempt him. He does not need us, but in times of travail we need him. He walks the right-hand path of white light and is the protector of all creatures great and small. His unseen hand works invisibly behind the scenes, changing the destinies of kings and peasants.

Transferring a Drawing

To begin the projects in this book, you might find it helpful to trace a basic outline of the final piece of art (or one of the early steps). Transferring the outlines of an image to your drawing or painting surface is easier than you may think. The easiest method for this involves transfer paper, which you can buy at your local arts and crafts store. Transfer paper is a thin sheet of paper that is coated on one side with graphite. (You can also create your own version of transfer paper by covering one side of a piece of paper with graphite from a pencil.) Simply follow the steps below.

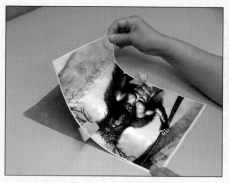

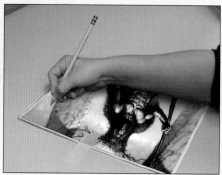

Step One Make a photocopy of the image you would like to transfer and enlarge it to the size of your drawing paper or canvas. Place the transfer paper graphite-side-down over your paper or canvas. Then place your photocopy over the transfer paper and secure them in place with tape.

Step Two Lightly trace the lines that you would like to transfer onto your drawing or painting surface. When transferring a guide for a drawing project, keep the lines minimal and just indicate the position of each element; you don't want to have to erase too much once you remove the transfer paper.

Step Three While tracing, occasionally lift the corner of the photocopy to make sure the lines are transferring properly. Continue tracing over the photocopy until all of your lines have been transferred.

The key to drawing a good wizard is the ability to construct a convincing human form and then layer it with character and imagination. I'll assume that most readers already know how to use a pencil and are familiar with rendering a simple value scale from dark to light. Understanding how to create a figure in black and white, as you will see in the future chapters, is invaluable. But without the fundamental knowledge of anatomy and proper proportion, your wizards won't look very realistic.

You can break down the construction of any figure into five steps. Step one is conception or the creation of a rough. What is it you want to draw? Step two is construction—the building of the basic form, including the skeleton. Step three deals with contour as you add details to the face and curves of the body. Step four is deciding on the direction of the light source and the mood of the character. Step five is making sure that the final figure works as a unit and that all the values are consistent.

Constructing a figure can be a painstaking process for the beginner. There's no magic pill to make someone a good artist. But with practice and a little patience, it will become easier and more natural.

When asked what is the single most important practice an artist can undertake to improve his or her craft, I always reply that it's the practice of figure drawing. When I was going to art school, I noticed that the students who were good at figure drawing tended also to be good in everything else, while those who focused mainly on still lifes, landscapes, and design weren't necessarily very good at drawing figures. The reason for this is simply that every

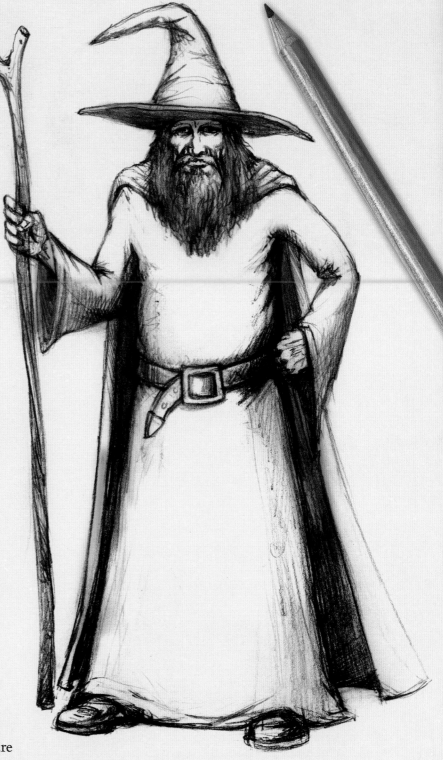

possible shape is contained in the human body, and no two bodies or faces are the same. There is nothing harder to draw well than the human figure. Master that and you're well on your way to becoming a skilled artist.

Drawing Basics

Before conjuring up our wizard, let's start with some basics.

A standard male figure is seven and a half to eight heads high. Females tend to be about seven heads high. Heroic fantasy figures all tend to have long legs, especially in anime-influenced characters.

Skeletons Drawing simplified skeletons is one of the most important skills you can learn in constructing figures.

Sketching Keep busy filling up your sketchbooks with hundreds of these skinny guys. When drawing female skeletons, remember that the hips are always wider than the shoulders.

Now it's time to create your standard, everyday wizard. Let's craft a template for creating future characters. The subject may change but the process will essentially remain the same.

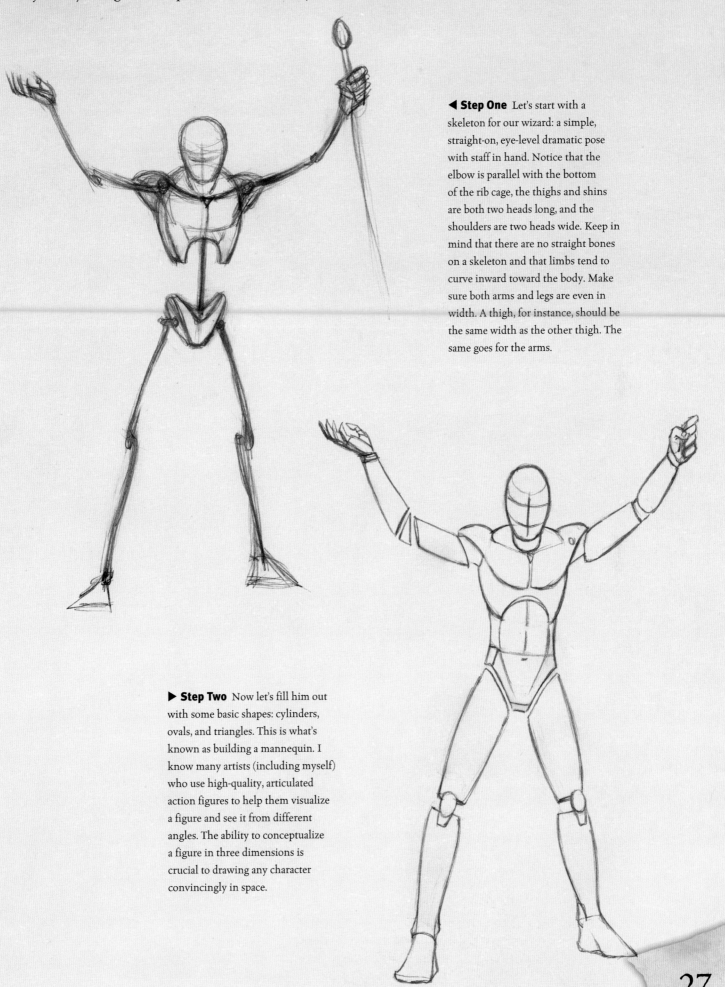

◄ **Step One** Let's start with a skeleton for our wizard: a simple, straight-on, eye-level dramatic pose with staff in hand. Notice that the elbow is parallel with the bottom of the rib cage, the thighs and shins are both two heads long, and the shoulders are two heads wide. Keep in mind that there are no straight bones on a skeleton and that limbs tend to curve inward toward the body. Make sure both arms and legs are even in width. A thigh, for instance, should be the same width as the other thigh. The same goes for the arms.

▶ **Step Two** Now let's fill him out with some basic shapes: cylinders, ovals, and triangles. This is what's known as building a mannequin. I know many artists (including myself) who use high-quality, articulated action figures to help them visualize a figure and see it from different angles. The ability to conceptualize a figure in three dimensions is crucial to drawing any character convincingly in space.

27

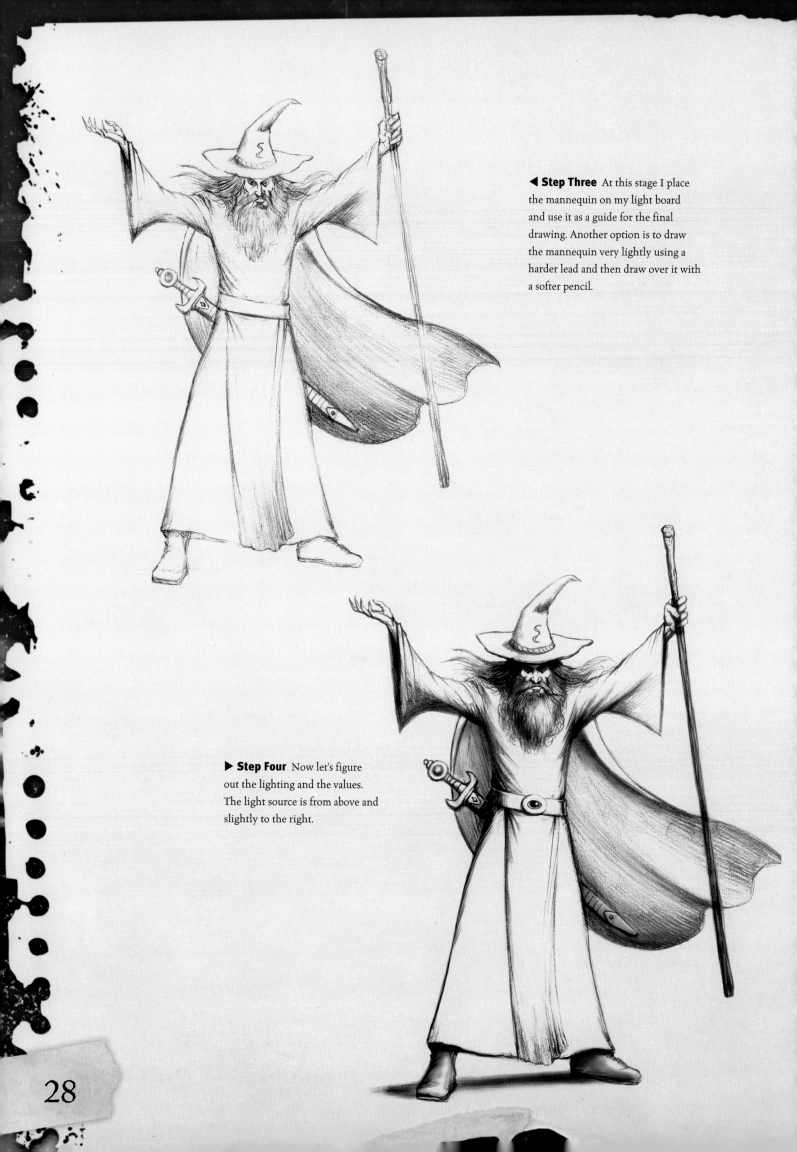

◀ Step Three At this stage I place the mannequin on my light board and use it as a guide for the final drawing. Another option is to draw the mannequin very lightly using a harder lead and then draw over it with a softer pencil.

▶ Step Four Now let's figure out the lighting and the values. The light source is from above and slightly to the right.

28

Here are some samples of wizard fashion, including hats, skull caps, crowns, cloaks, belts, and a gauntlet.

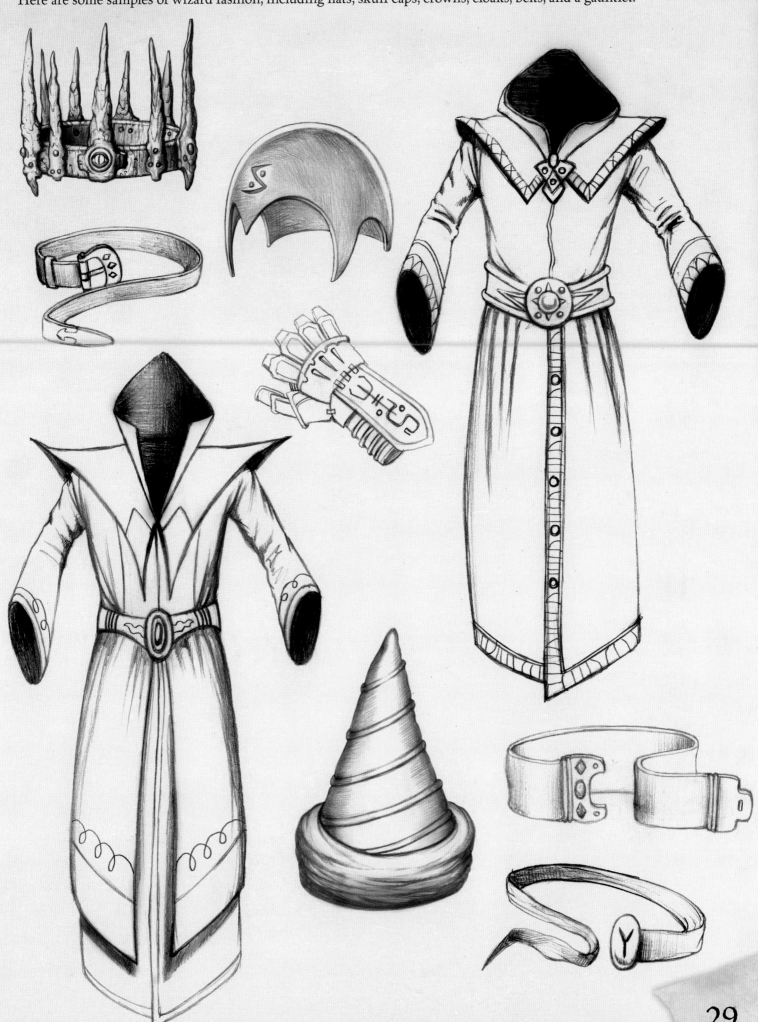

The Wizard's Grimoire

A wizard uses many tools in his line of work. We'll get to many of them in later chapters, but for now we'll focus on three of the main tools in his arsenal: the grimoire, the wand, and the staff.

Grimoires were commonly called "Black Books." They came into major use during the Middle Ages and the Renaissance. All grimoires during these times were handmade and copied over and over by scribes. The wizard's collection of grimoires was the centerpiece of his power and knowledge. Inscribed on their dusty pages were all the exact instructions for numerous spells, incantations, and rituals.

The grimoire was also a diary where the wizard recorded his life's work, knowledge, and hard-won occult secrets. Additionally, it was a compendium of everything from recipes for potions, oils, and incense to a fantastical bestiary accompanied by drawings describing demons, spirits, and angels that the wizard had conjured up over his lifetime. In many ways an artist's sketchbook is a grimoire of sorts in which all of his or her musings and thoughts and even secrets are rendered.

Because of the occult power contained in a grimoire, it was of utmost importance to keep it away from unwelcome, untrained eyes. So for this next project, I want to design a fearsome book that only the most foolhardy would dare to open. First I'll draw the grimoire, and then I'll scan it and use Photoshop® to add the finishing touches. If you are unfamiliar with some of the Photoshop tools I'll be using, simply refer to the chapter on digital painting (page 77).

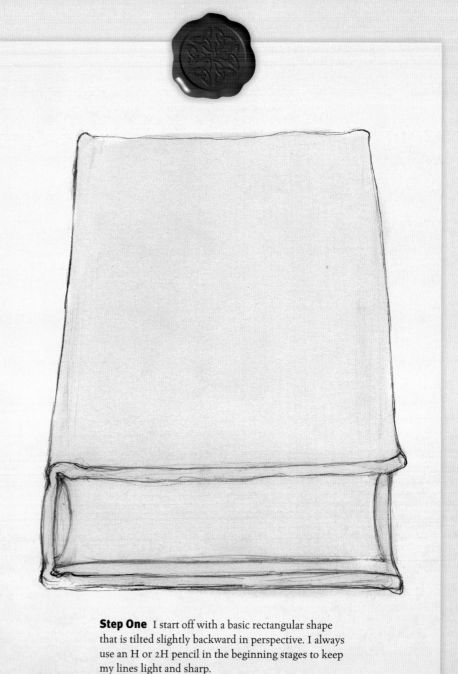

Step One I start off with a basic rectangular shape that is tilted slightly backward in perspective. I always use an H or 2H pencil in the beginning stages to keep my lines light and sharp.

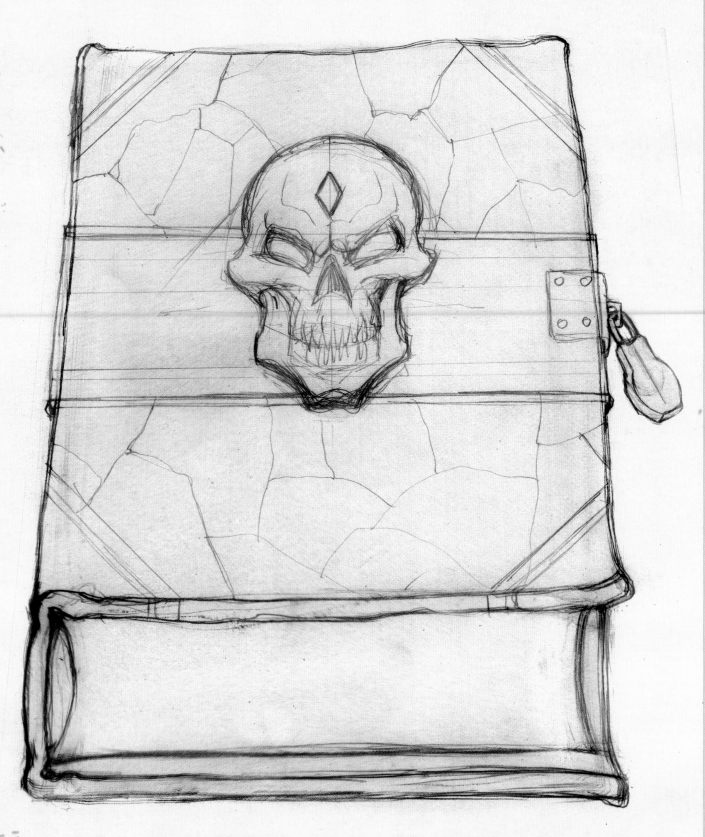

Step Two Now I start to add some detail. Since we want the grimoire to look ominous, I want the cover to be stitched together by something other than leather. I'll let you guess what that is. Adding a skull with glowing eyes and evil intent will also be a good deterrent.

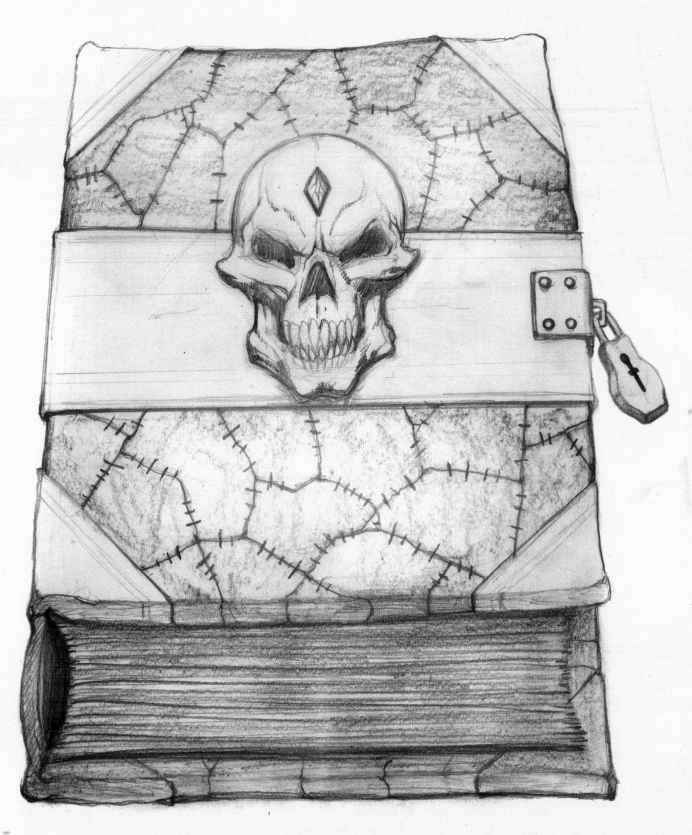

Step Three Now I add some texture and deepen the values. For the darkest darks, I use a softer HB pencil. One of the keys here is to make things look organic. The book is a rectangle, but avoid solid, straight lines. We want this grimoire to look ancient and worn, thick with the decay of the ages.

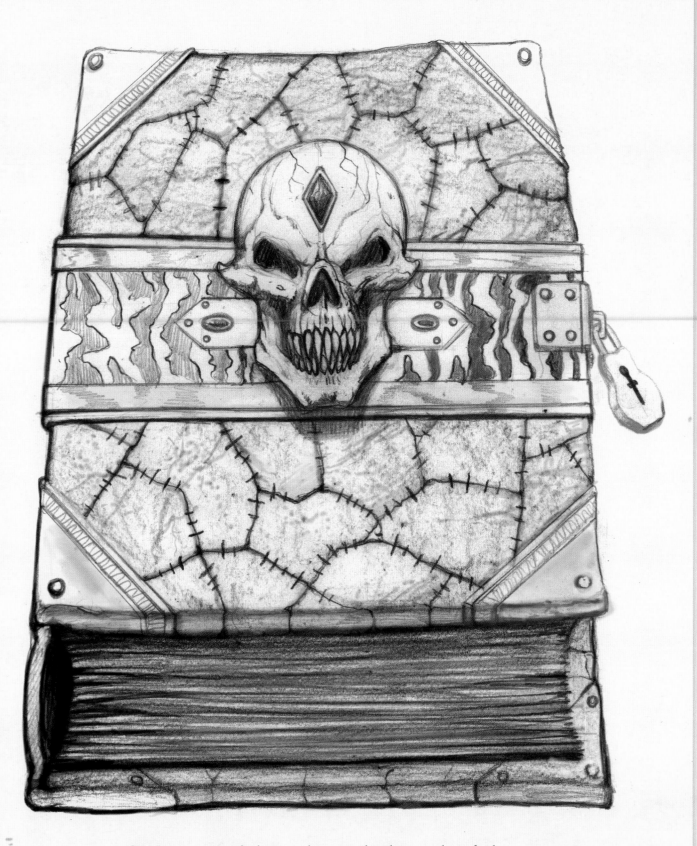

Step Four Now I scan the drawing and open it in Photoshop at 400 dpi. To finish I use only three tools: the paintbrush, the Dodge tool, and the Burn tool. These are the three tools that are used the most in digital painting so now's the time to start practicing with them. The important thing about this exercise is that you learn to render an image in black and white; this is the first stage that has to be conquered if any painting is going to look right in color.

Step Five Using the Burn tool with the brush size set at 300% and the exposure at 40%, I lightly darken the cover. Using the Dodge tool with the brush size set at 20% and exposure at 30%, I gently pick out areas that I want to highlight. I want to build up contrast so the image will pop and look sharp.

Step Six I do the same for the skull, keeping in mind that the light is coming from directly above. I paint in some pinprick-sized eyes and make them glow.

Step Seven I want the pages to look ragged, so I use the paintbrush tool to stroke in black lines with the brush size set at 15% and the opacity between 20% and 30%. I don't want perfectly straight lines here so I keep it loose. Finally, I go in with the Dodge tool set to low and stroke in lighter lines.

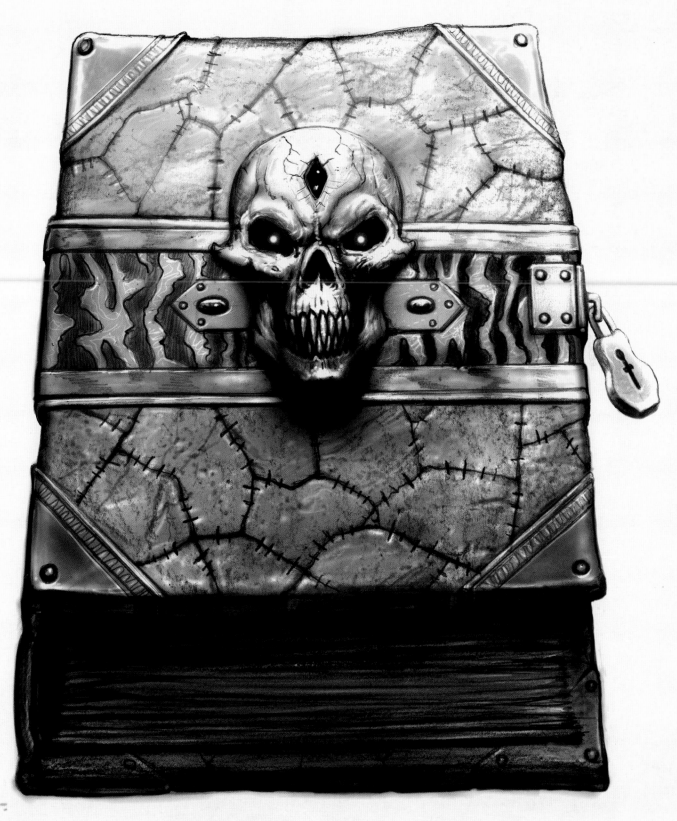

Step Eight Feel free to add as much detail as suits your fancy. Look for spots where you can deepen a shadow and brighten a highlight. The key is knowing when to stop. Just remember that the image as a whole should never be sacrificed for the details.

The Wizard's Tools

The wizard's most important tools are his staff and wand. They are similar in that they contain the wizard's essence and power, but the staff contains more of the wizard's personal energy. His staff is like a reliable companion and loyal friend that supports him on his many travels to distant lands.

The wand, on the other hand, is more specialized and disposable. Some wands are used for healing and some wands are used for evil. Some wands simply channel and direct the wizard's innate energy, increasing his power, whereas other wands can be used to steal the energy and life force from another wizard.

Wand

A wizard's wand is one of his most important tools and is most often associated with wisdom and prophecy. Wands should be fashioned from either wood or metal because their most important trait is conductivity. Bronze was the most common metal used in wand making, but silver and gold work as well. Here are a few different styles of wands to inspire you.

Many wands were embedded with jewels or animal bone to represent the different elements. For example, a wand used to control the element of air would be decorated with feathers. But most important, a wand was the personalized image of the wizard himself. You should be able to look at a wand and tell what kind of wizard owns it, for it serves as a channel for the wizard's power, allowing him to manifest his magical desires.

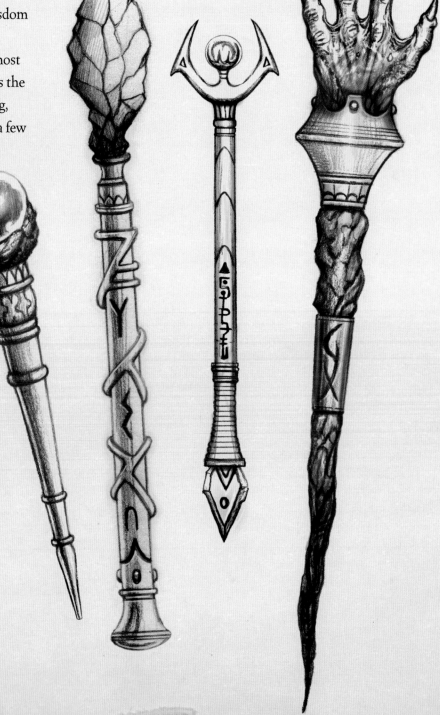

Staff

The wizard's staff is even more important and personal than his wand, as it contains more of his spiritual essence than any other ceremonial or magical object. For this reason alone, the breaking of a wizard's staff could be a fatal blow. He may possess only one or two staffs during his entire lifetime.

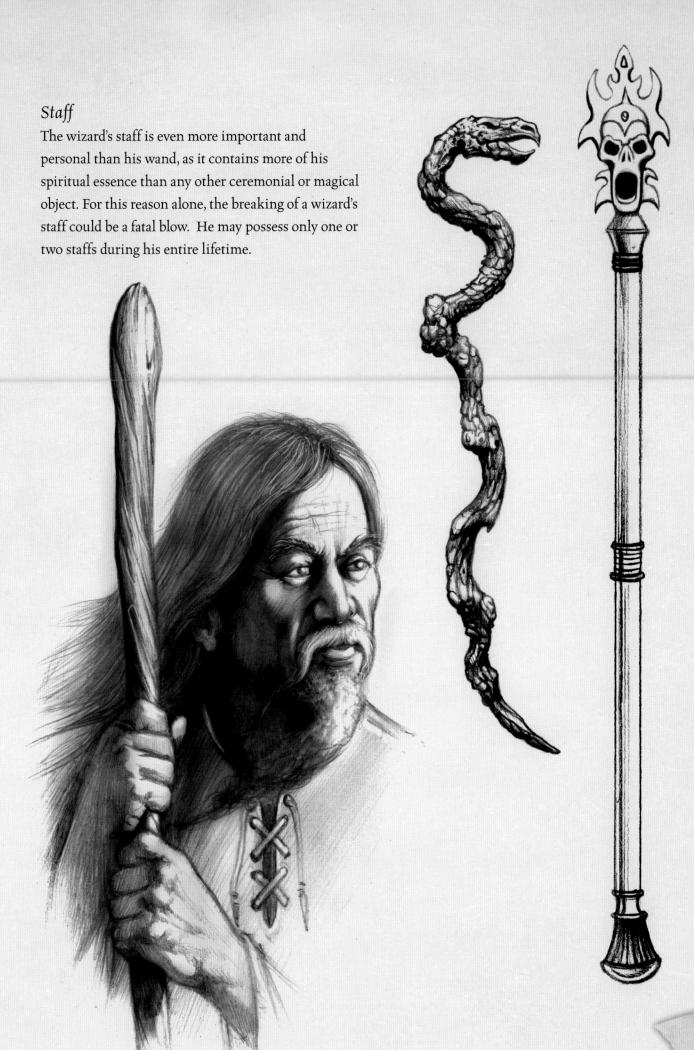

The Wizard's Sanctum Sanctorum

Sanctum Sanctorum translated from Latin means "a place of utmost solitude and inviolability." To pursue his magical arts, a wizard needs a place where his studies will not be disturbed or violated; a place filled with all sorts of magical objects and books of lore; a place where he can weave spells and invoke spirits without disturbance from nosy outsiders.

Bridge Before we enter the wizard's workshop we must first cross the bridge into his world and breach his first line of defense—the tower.

Wizards do not rely solely on magic for their knowledge. They also study science and nature, including biology, astronomy, and zoology. They are collectors of all sorts of artifacts, ranging from seashells and crystals to bones and butterflies. Everything in the universe is open to observation and cataloging.

◀ **Wizard's Tower** The wizard's tower is specifically designed to keep the overly curious at bay. It is a sacred, distant haven that in some cases can only be reached by magical means.

▶ **Wizard's Door** Even if one can reach the wizard's tower and gain entry, one must still open the door to the Sanctum Sanctorum, which is usually protected with spells and maybe a demon or two. Dare to enter at your own risk.

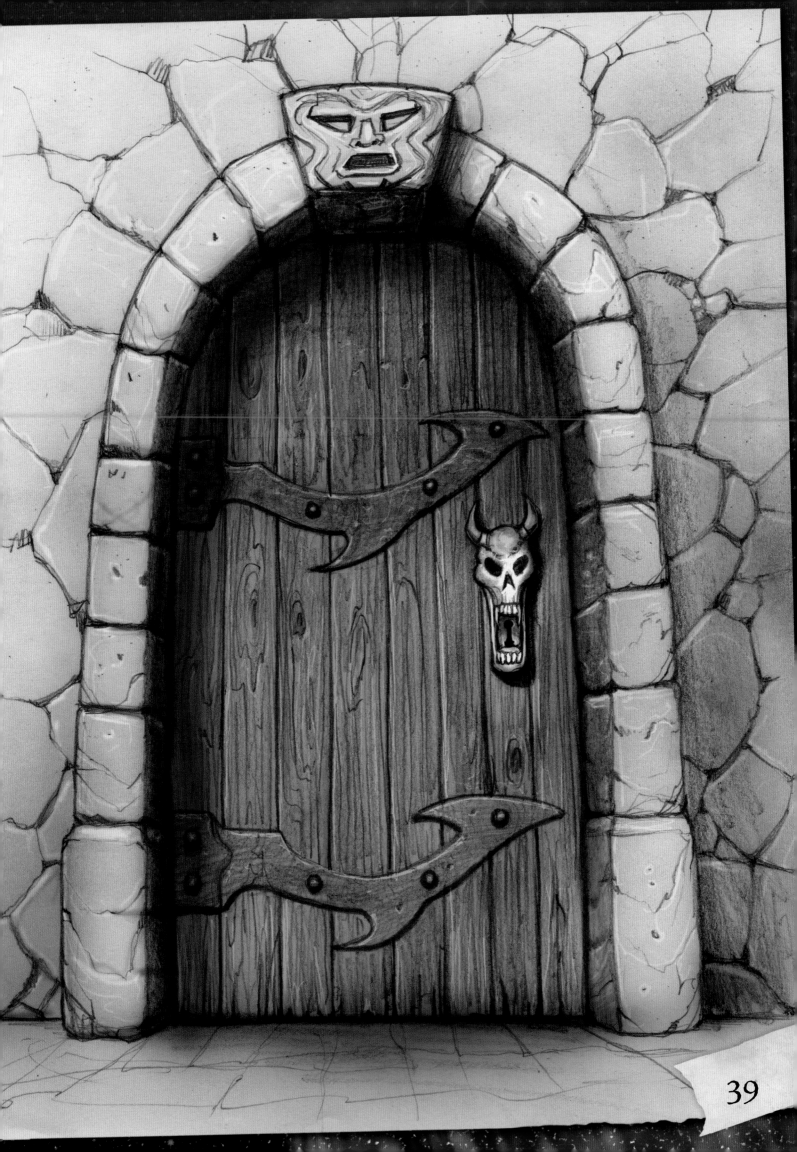

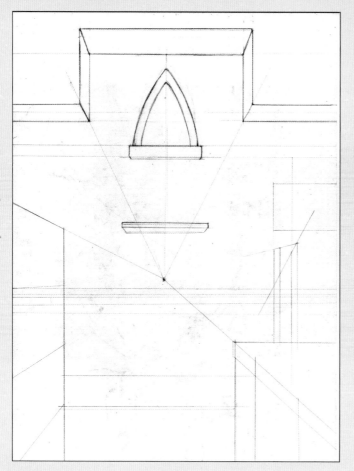

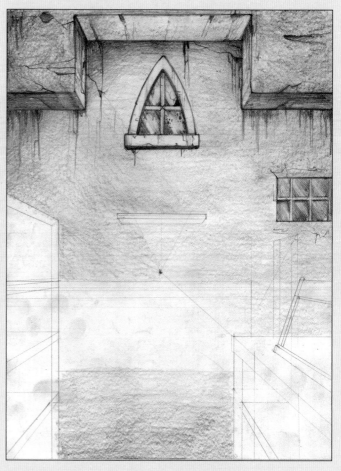

Step One Let's create our own Sanctum Sanctorum. I start using one-point perspective, which dictates that all lines perpendicular to the picture plane converge at a single point (the *vanishing point*), which is where the wizard's head will eventually go. Using this method I construct a realistic three-dimensional space.

Step Two Working back to front, I start rendering the window using an HB pencil. In this case I use one pencil for the whole drawing. I want the workshop to look old and well-used with lots of different textures.

◀ **Step Three** At this point I jump to the foreground elements because I want to get a sense of where to place the wizard and the accompanying lighting effects. I plan to use a single candle as the light source so I need to have a clear idea of how I want to pose the wizard. Note that his shelves are filled with all sorts of weird and curious objects. And what wizard wouldn't want to possess a wand holder?

▶ **Step Four** I draw the wizard sitting at his desk contemplating a skull and his own eventual mortality. Every wizard needs a familiar, so I add a watchful raven. Designs are scrawled on wall charts, and there is a magic mirror to his right.

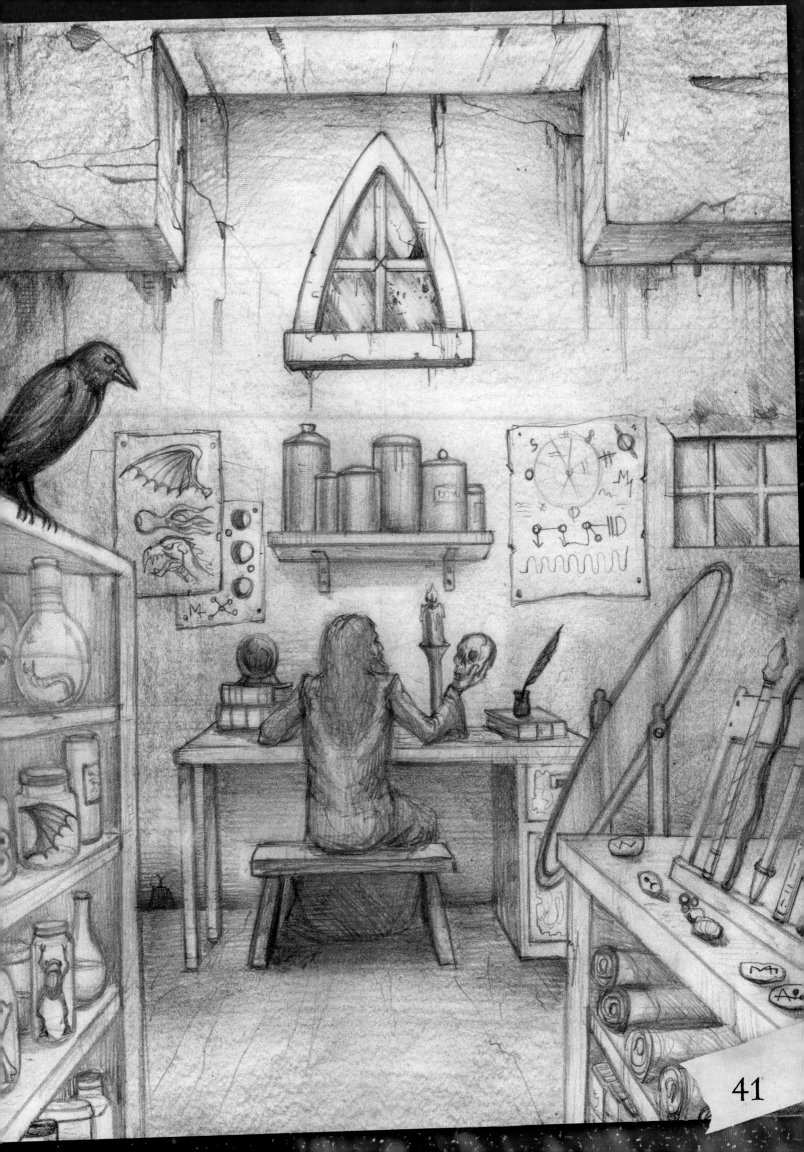

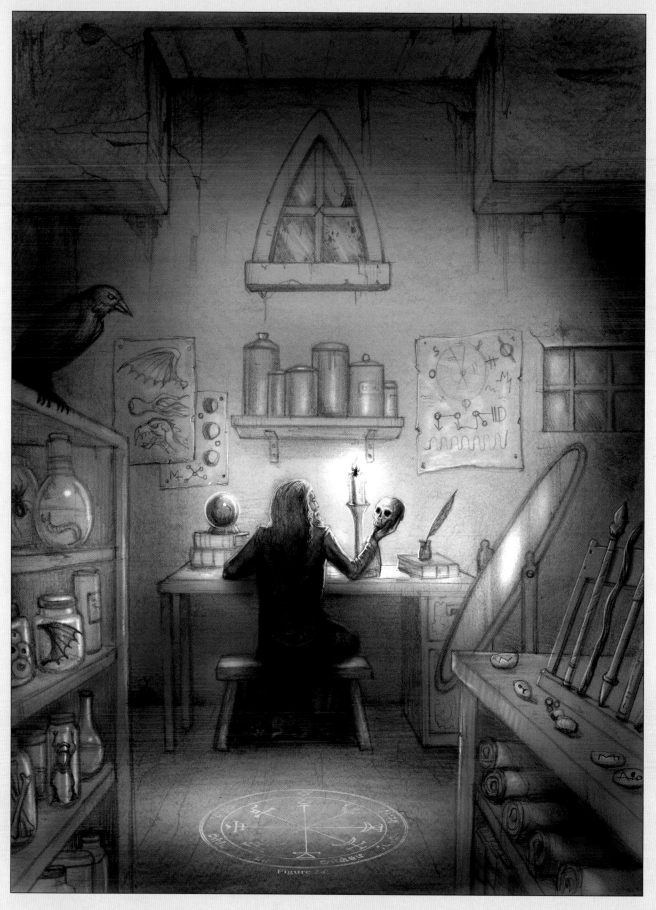

Figure 24.

Step Five At this point I scan the drawing and add some final touches in Photoshop. To get the full effect of the candlelight I use the Burn tool with a large brush and darken the edges of the drawing to create a nice pool of light in the middle. Again using the Burn tool, I brighten up the desk and add edge lighting (an effect used in most fantasy paintings that involves outlining the contours of figures to make them stand out from the background) to the wizard. On a separate piece of paper, I draw a magical circle and scan it in. In Photoshop, I click on Invert at the bottom of the Adjustments menu so the dark pencil is now white. I select the circle using Color Range from the Select menu and place the circle on the floor behind the wizard. Scaling it down using the Perspective tool in the Edit menu, I eyeball it until it looks right. Then I take the circle's opacity down to 60% so it will blend in with the floor. As a finishing touch, I add a snoozing cat beneath the wizard's bench.

The Magical Oracles of the Wizard

A wizard uses a variety of smaller but no less valuable tools to aid him in gathering power and divining his destiny. The main tools are crystal balls, mirrors, and Tarot cards. Note that a wizard practicing white magic is not a fortune teller, nor is he interested in having his fortune told. The white wizard is most interested in self-knowledge and acquiring occult knowledge. A dark wizard practicing black magic is only interested in acquiring power and then more power. All of the dark wizard's tools exist for that devious purpose.

The Magic Mirror

The magic mirror was also known as a speculum, and is one of the oldest of the wizard's tools. There are two types of speculums; both were wrapped in silk and could never be taken out into the sunlight. Only moonlight and candlelight could illuminate the mirror. Wizards would gaze for hours into these mystic mirrors looking for signs, wonders, and glimpses of far-off places and hidden realms.

▶ **Framed Mirror** One type of speculum was an ordinary glass mirror circled by a magical frame. The reflective glass was bathed in special oils and herbs and then polished to a clear shine.

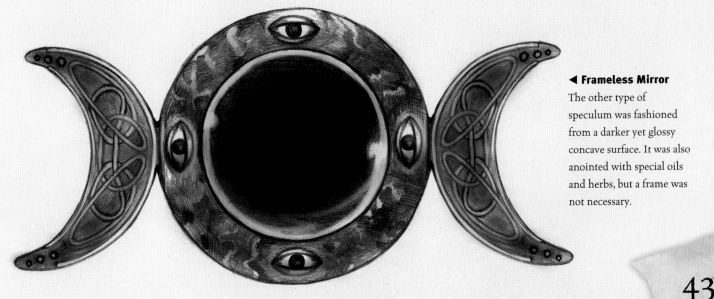

◀ **Frameless Mirror**
The other type of speculum was fashioned from a darker yet glossy concave surface. It was also anointed with special oils and herbs, but a frame was not necessary.

The Crystal Ball

The crystal ball serves a similar purpose as the magic mirror. Sometimes the wizard would voice a question directly to the crystal ball and then gaze into its depths seeking an answer.

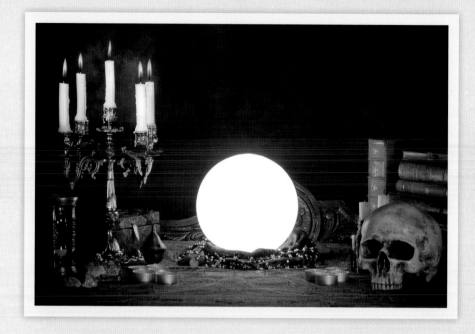

▼ **Crystal Balls** Crystal balls were usually fashioned from natural quartz of varying colors and polished to a high brilliance. Being round, they were considered feminine in nature. The stand that holds the sphere is almost as important as the sphere itself. A stand could be made from wood or pewter and inspired by everything from dragons and eagles to roses and vines, depending on the personality of the user.

The Tarot

The Tarot is a deck of 78 cards used in mystical readings since the 14th century. The Tarot deck is made up of two specific sets: the Major Arcana and the Minor Arcana. Going through the deck from 0 to 21 is thought to represent a map of the spiritual journey from ignorance to enlightenment. I highly recommend studying the Tarot, especially if you have an interest in fantasy art. The samples below are taken from the Rider Waite deck, the most popular rendition of Tarot to date and first published in 1909.

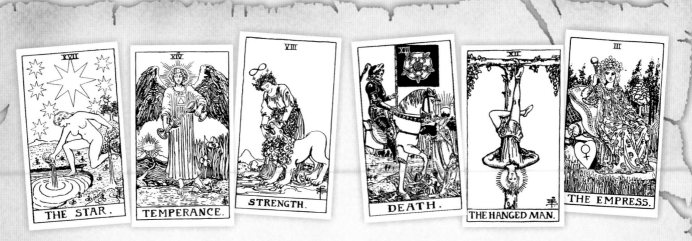

Minor Arcana The Minor Arcana are made up of four suits: cups, wands, swords, and pentacles.

Major Arcana The Major Arcana contain symbolic pictures depicting ancient archetypes and are considered to be the most powerful cards in the deck.

Designing Your Own Tarot Card

In this project I will design my own Tarot card, taking time to delve into the symbolism involved so the card's meaning is clearly understood. I recommend creating your own Tarot cards using symbolism and objects that mean something to you and then using them as a source of inspiration. The Magician could be female, or it could be a scientist, a juggler, or a dancer—it's up to you.

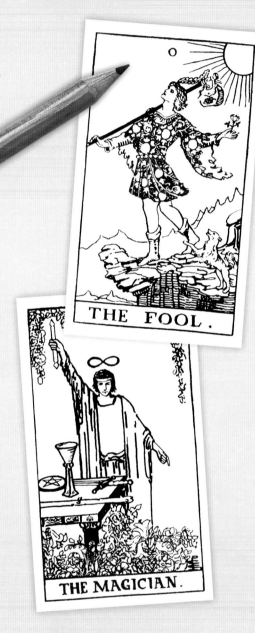

◀ **The Fool** The card that concerns us in the upcoming project is card number 1, which comes after the fool (represented by the number 0).

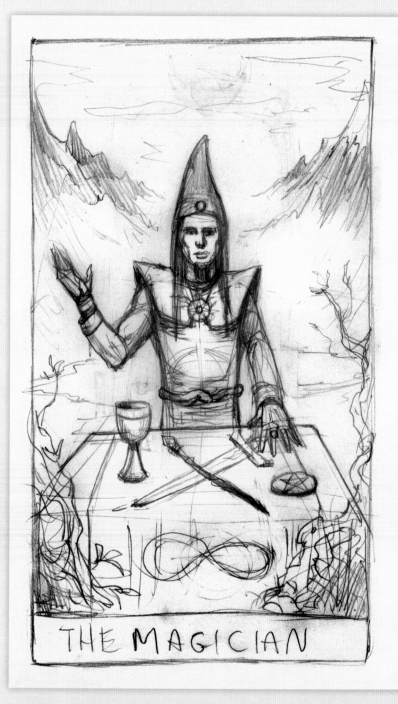

▲ **The Magician** This card is known as the Magician, or card number 1. The Magician can also be interpreted as the Wizard card and is the card closest to representing the artist. Interestingly, the Magician is the Fool's companion on his journey toward enlightenment and represents the subconscious mind in human form. The Magician is the messenger of the gods and a channel for the divine. He taps into heavenly revelation and knowledge and brings it to Earth. He manifests miracles.

Step One Scribbling out a rough, I include all the elements and symbols that go with the Magician. It's okay for the card to feel a little stiff and formalized since this works with the style and tradition of the Tarot.

Step Two Now let's get to work on the final, starting with the background. Traditionally mountains represent knowledge and austerity; they are the perfect backdrop for the Magician. To create a sense of sweeping upward, the mountains curve up toward the sky. Next we add stylized clouds representing elevated thoughts and dreams.

Step Three Next we move to the foreground. In one corner a white rose representing purity blooms on a branch. A bush grows in the other corner representing growth and the fecundity of nature. In many ways all these elements work together to create a framing device for the figure of the Magician soon to come. The table is drawn next in which the Magician will lay out his symbols and tools of power.

47

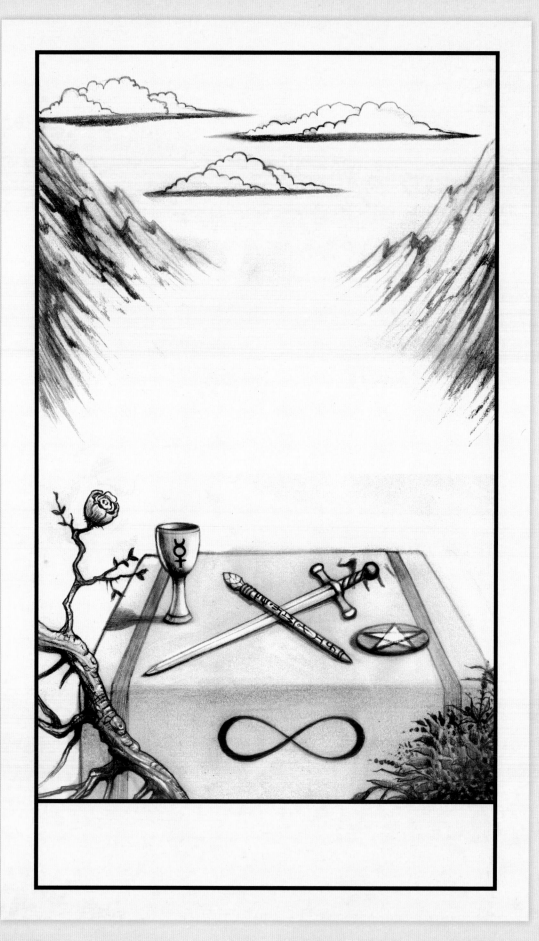

Step Three Now comes the fun part. We draw a chalice, a sword, a wand, and a pentacle representing the four suits of the Tarot deck. The Magician is considered the master of all their powers and subtle energies. The chalice, or cup, represents the element of water and the emotions. The sword represents the element of air and the power of thought and willpower. The wand represents fire and the power of ideas, creativity, and inspiration. The pentacle represents the earth element and symbolizes the material world and man's place in it. On the front of the table we draw a figure eight, also referred to as the infinity symbol or the Lemniscate. It symbolizes the endless, indestructible nature of energy.

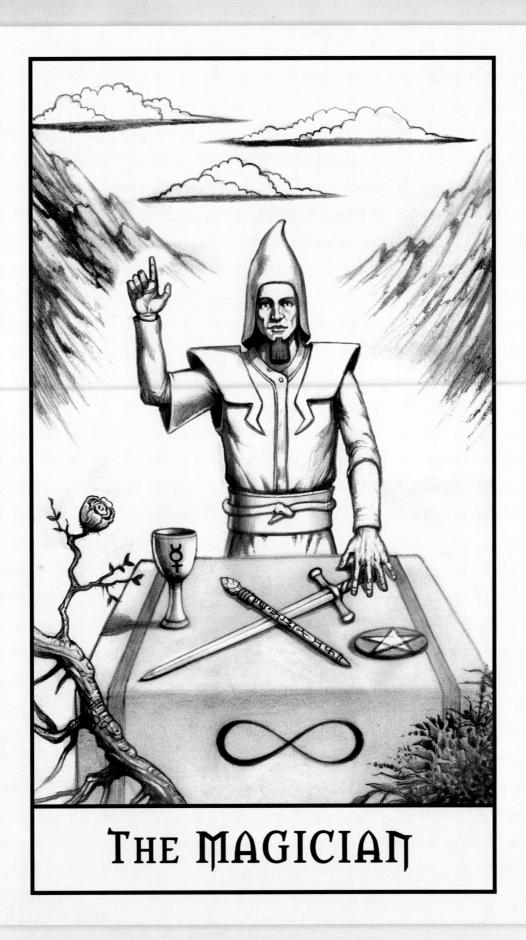

THE MAGICIAN

Step Four Finally, the Magician enters the scene. His pose is formal, even stiff, giving him an almost priestly mantle of authority. It's normal for Tarot figures to look posed since they are stand-ins for ancient mystical archetypes. The Magician's right hand points upward, as he is drawing down cosmic energy. His left hand, fingers spread, brings the energy down to Earth. His expression is relaxed and calm. He is in total control. His belt is fashioned from a serpent with its tail in its mouth, called an Ouroboros, which represents creative energy and the power of cycles known as eternal return.

Familiars & Practical Demon Summoning

Every wizard needs a familiar, or a companion of sorts to keep him company during his long lonely hours of study and meditation. A true familiar is an animal to which the wizard is deeply bonded and feels spiritually connected. For this reason a familiar is attached to one specific wizard and that wizard only.

Common familiars are the dog and cat. Other less-common familiars are owls, ravens, ferrets, possums, bats, mice and rats, and even snakes, turtles, lizards, frogs, and the occasional spider.

frog

horned owl

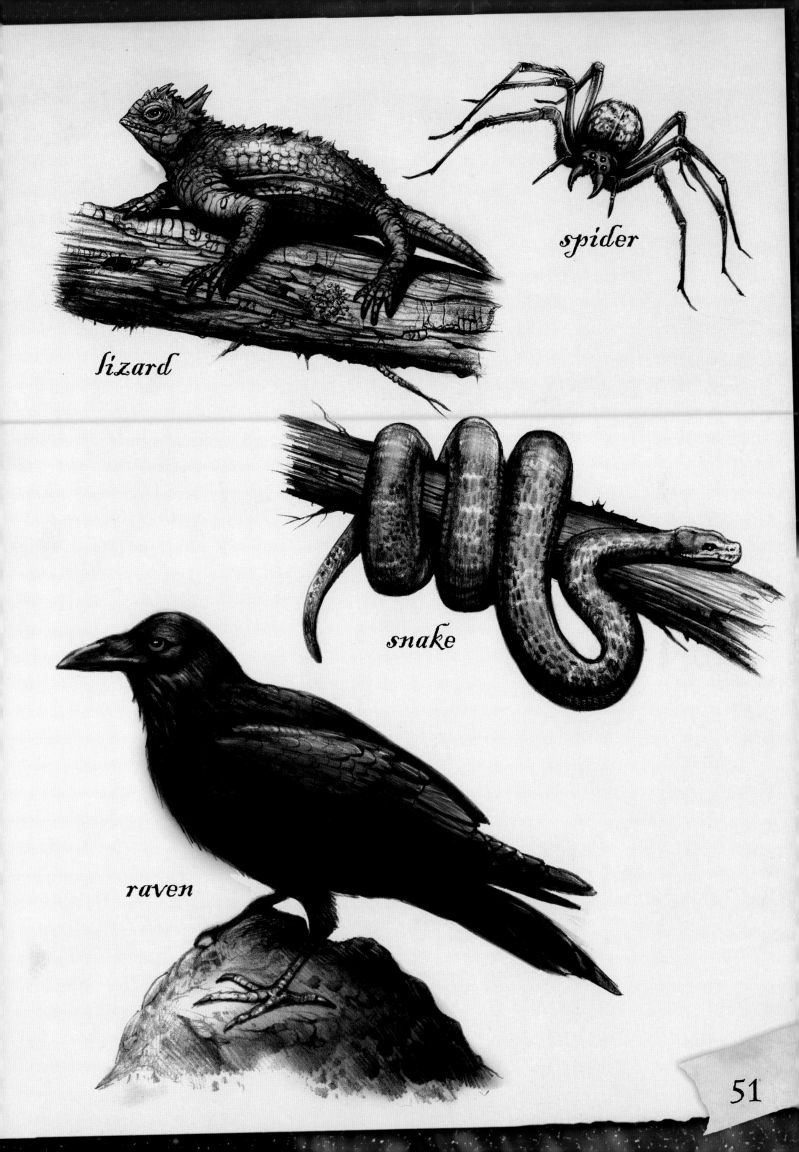

lizard

spider

snake

raven

51

The Art of Summoning

A wizard generally summons three kinds of entities: a disembodied spirit of some type, a demon, or an angel. If a wizard conjures up an undead spirit, he's working in the dark undead realms of necromancy, which we will deal with more fully in the next chapter. In this project, the wizard will conjure up a demon from the netherworld to do his bidding. It goes without saying that demons are quite crafty and untrustworthy, so you can never turn your back on them for a second. Nevertheless, they can be coerced into revealing occult knowledge and the secrets of nature if prompted correctly.

The first thing I need to create is a ritual space, which will be constructed from a circle containing a triangle. I draw magical inscriptions of containment and protection all around the periphery to make sure that whatever demon I conjure up remains imprisoned there.

▲ Step One Circles are usually drawn on the floor with a thick chalk. The circle cannot be broken, or the demon will be able to slip through and wreak havoc in our world. This is one of the main reasons for drawing a double outer circle to be safe.

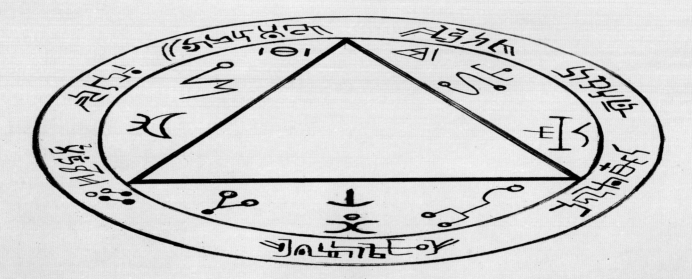

Step Two Now I draw the same circle in perspective, known as an ellipsis.

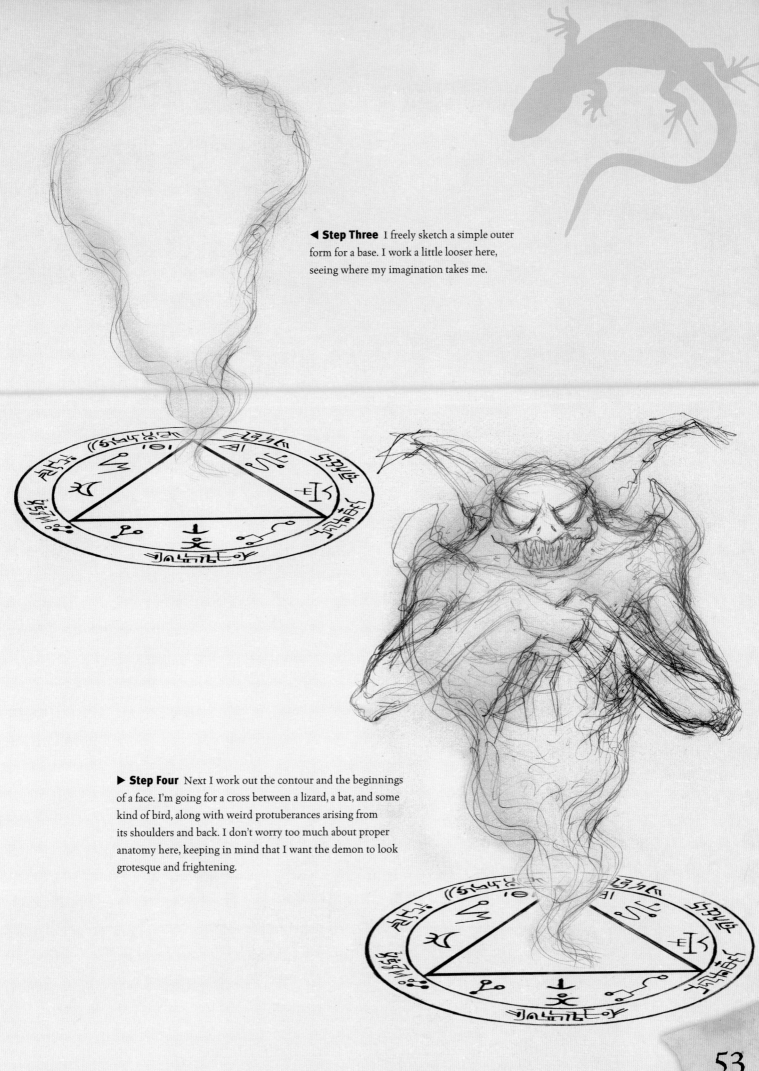

◄ **Step Three** I freely sketch a simple outer form for a base. I work a little looser here, seeing where my imagination takes me.

▶ **Step Four** Next I work out the contour and the beginnings of a face. I'm going for a cross between a lizard, a bat, and some kind of bird, along with weird protuberances arising from its shoulders and back. I don't worry too much about proper anatomy here, keeping in mind that I want the demon to look grotesque and frightening.

53

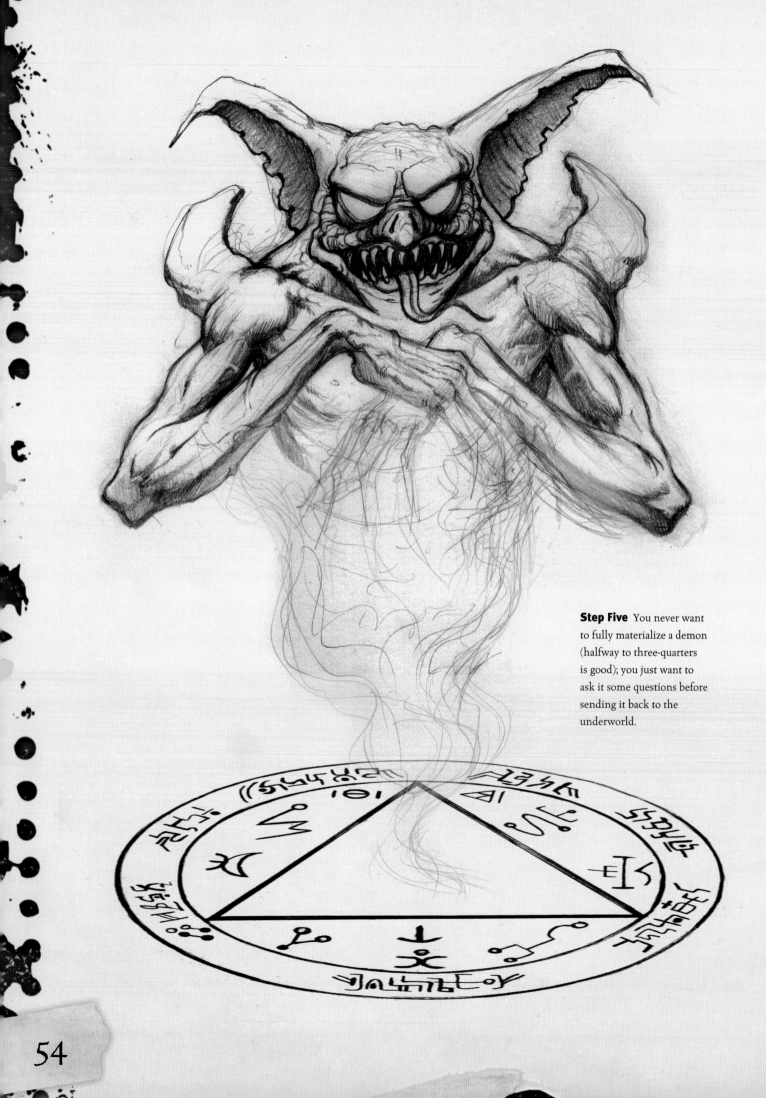

Step Five You never want to fully materialize a demon (halfway to three-quarters is good); you just want to ask it some questions before sending it back to the underworld.

54

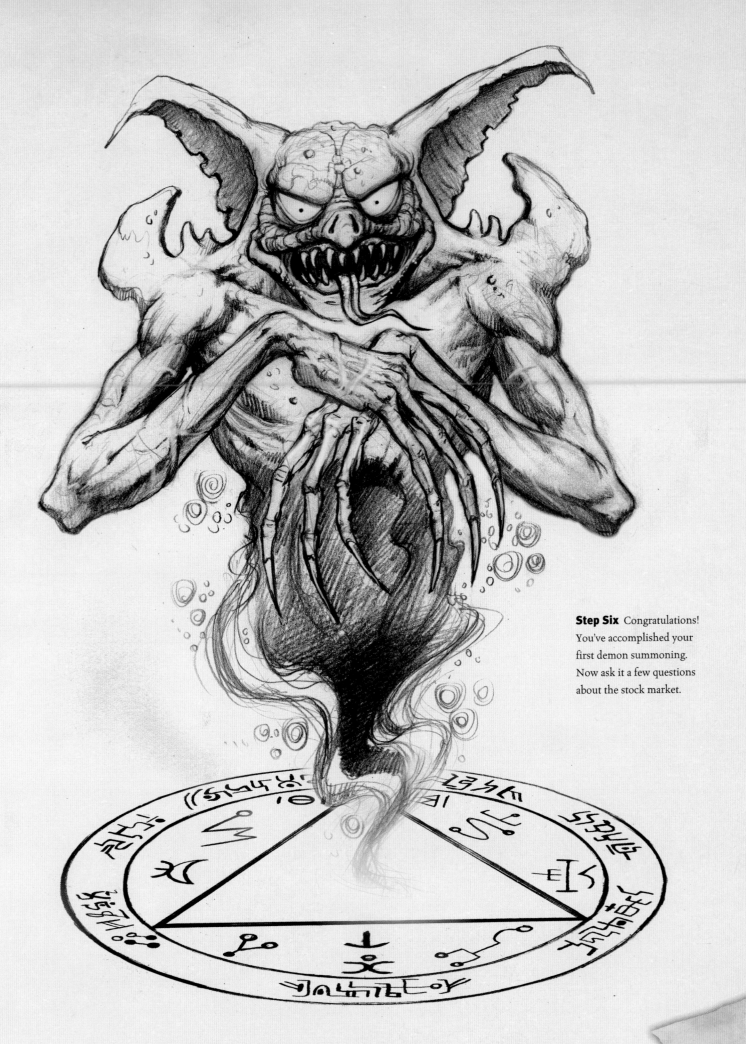

Step Six Congratulations! You've accomplished your first demon summoning. Now ask it a few questions about the stock market.

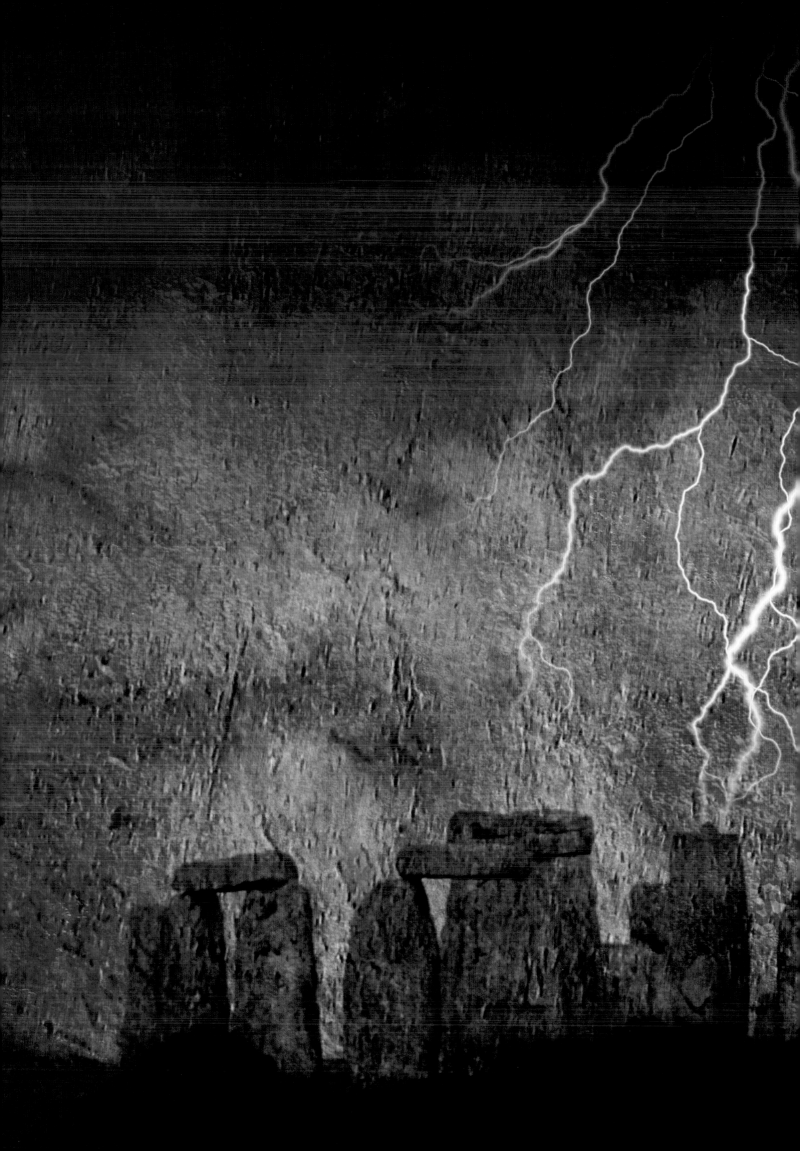

Chapter 3:
Introduction to Painting
in Oil & Arylic

O nce you've become proficient in drawing, you can move on to painting, which presents a whole new set of challenges. I highly recommend learning to paint monochromatically so you can first learn to master the medium instead of being overwhelmed by color.

When beginning artists first learn to paint they tend to make the same mistakes over and over. The main one is the tendency to pile on paint way too thick right from the beginning. In a short time, the painting turns into a pile of sludge, and the budding artist stares into his or her canvas blankly, confused as to how this could have possibly happened.

The key is in learning the proper handling of the thickness and thinness of paint, its transparency and opaqueness, and its careful application to the canvas. Gentleness is a positive virtue at this stage.

The same principles that apply to using real paint also apply when using Photoshop. For this reason alone, every painter will be doing himself or herself a big favor by first learning to use real paint and brushes before making the jump to digital.

I cannot over-emphasize that success in painting comes from the careful control and skill in the thickness and thinness of your paint. Skillful painting comes from building up consecutively thicker layers. Each painting is like constructing a house; it's built step by step, brick by brick, as you move from a firm foundation to the roof.

There are no shortcuts in painting and no special tricks—just vigilant, open-eyed observation combined with hand-eye coordination. This takes time to master, so be patient. But know that once you master a technique, it never leaves you.

Painting Materials

Painting has been around for a long time, but artists to-day have many advantages and luxuries that the great masters of the past didn't have. A hundred years ago, before the invention of acrylic paint and the next generation of oil paint, artists were limited to a very narrow palette of colors consisting mainly of earth tones. Ever wonder why all of Rembrandt and Da Vinci's paintings possess that warm sepia look? Now you know.

Artists of their time also had to make their own brushes and grind up colors for paint. We get impatient if we have to stand in line at the art store. Today there is a wide array of amazing colors and brushes to choose from—almost too many.

Mastering the medium so it doesn't master you is one of the keys to creating a successful painting. You're working with temperamental liquids, gels, and pastes. You have extensive choices in painting surfaces and brush types. All of them will contribute to the final result. Be patient and count on a fair amount of trail and error until you get something you're satisfied with.

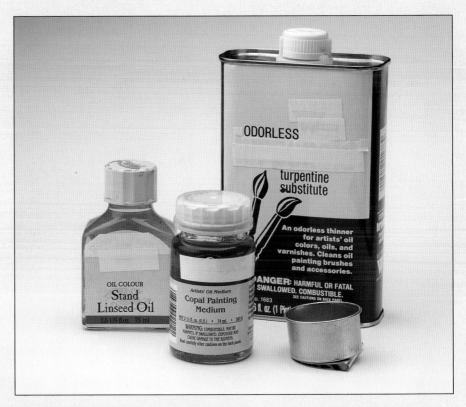

Mediums The mediums I like to use for oil painting (from left to right) are odorless paint thinner, Liquin™, and cobalt drier. Never use paint thinner unless it's odorless. I prefer Liquin to linseed oil because it's much clearer, dries faster, and is less expensive. Cobalt drier is an illustrator's best friend as it drastically shortens the drying time for oils. Use it carefully.

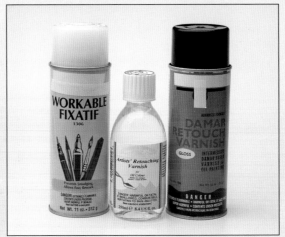

◀ **Spray Varnish** I use spray varnish to protect my paintings and to even out the colors. When you spray, keep a safe distance from the canvas and use a variety of strokes. The last thing you want is a glob of varnish pooling in the middle of your painting.

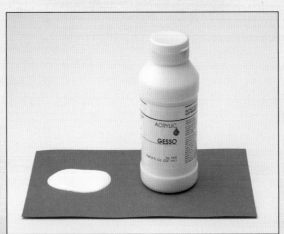

◀ **Gesso** I like to use gesso that is fairly thick so I can thin it down according to my needs. Since I use about three or four layers to cover a Masonite board, I dilute each layer slightly for a smoother effect. Then I go in with fine sandpaper to smooth out any rough spots.

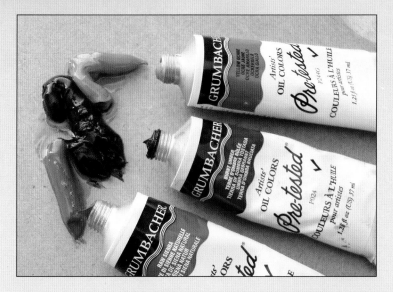

Oil Paint I prefer Winsor & Newton™ and Grumbacher® brands for oil paints. I don't work with water-soluble oils because I find that they become too sticky and dull to work with when trying to blend smooth transitions.

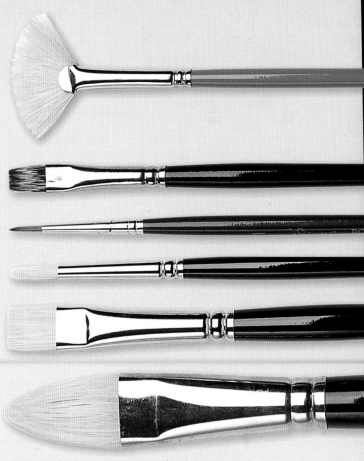

Acrylic Paint I prefer Liquitex® and Golden® acrylic paints. Cheaper brands have a tendency to become muddy and look dull. Black in particular can turn brown when diluted.

Brushes I like to use a mixture of sable and synthetic brushes. When painting with acrylics, cheaper, stiffer brushes can work fine. But when working in oils, softer brushes are the way to go, especially when painting skin tones and finer details.

Watercolor Pencils Watercolor pencils come in handy near the end of a painting for finishing touches. I use them for hair, fine details, and straight lines.

Painting Large Areas When painting bigger sections I like to use fairly large brushes. I use fan brushes for smooth, airy effects; I also use wide, flat brushes for painting skies and large patches of clouds and mist. I'll often use a wide soft brush with no paint on it to blend separate colors together for a smooth transition.

Brush Cleaner Brush cleaner is important not just for the longevity of your brushes but also for cleaning your hands. I often use a toothbrush to get under my fingernails.

Necromancer

Of all the arts of wizardry, necromancy (or the summoning and raising of the dead) was considered the most difficult and dangerous. Conjuring up the dead was a supreme feat of magic and the highest test of a wizard's abilities. Necromancy not only included animating the dead but also contacting and controlling demons and spirits from the netherworld.

The motivations of necromancers are not easy to understand. Some sought to outwit the Grim Reaper by attempting to reanimate loved ones who were taken before their time. Some simply wished to create undead slaves to do their bidding. Others called upon spirits to learn the hidden occult knowledge that only the dead possess.

It was believed that the dead still lingered near their resting places long after their burial. This made graveyards, mausoleums, and even ancient battlefields the perfect places for necromantic ceremonies. During these ceremonies, elaborate rituals and arcane tools of the occult were used. Every precaution had to be taken or the necromancer could become prey to the very forces he sought to dominate and control. Playing God has its price.

Palette

This project will be painted entirely in acrylic. I'll only be using four colors:

Mars black
titanium white
cerulean blue
medium magenta

Always remember that you have to work quickly with acrylic because the paint becomes tacky and hard to blend after three to four minutes. Keep practicing—you'll get it. I suggest using a smaller piece of canvas at first and practicing this technique over and over until you get it right. The bigger the painting, the harder it is to blend large areas.

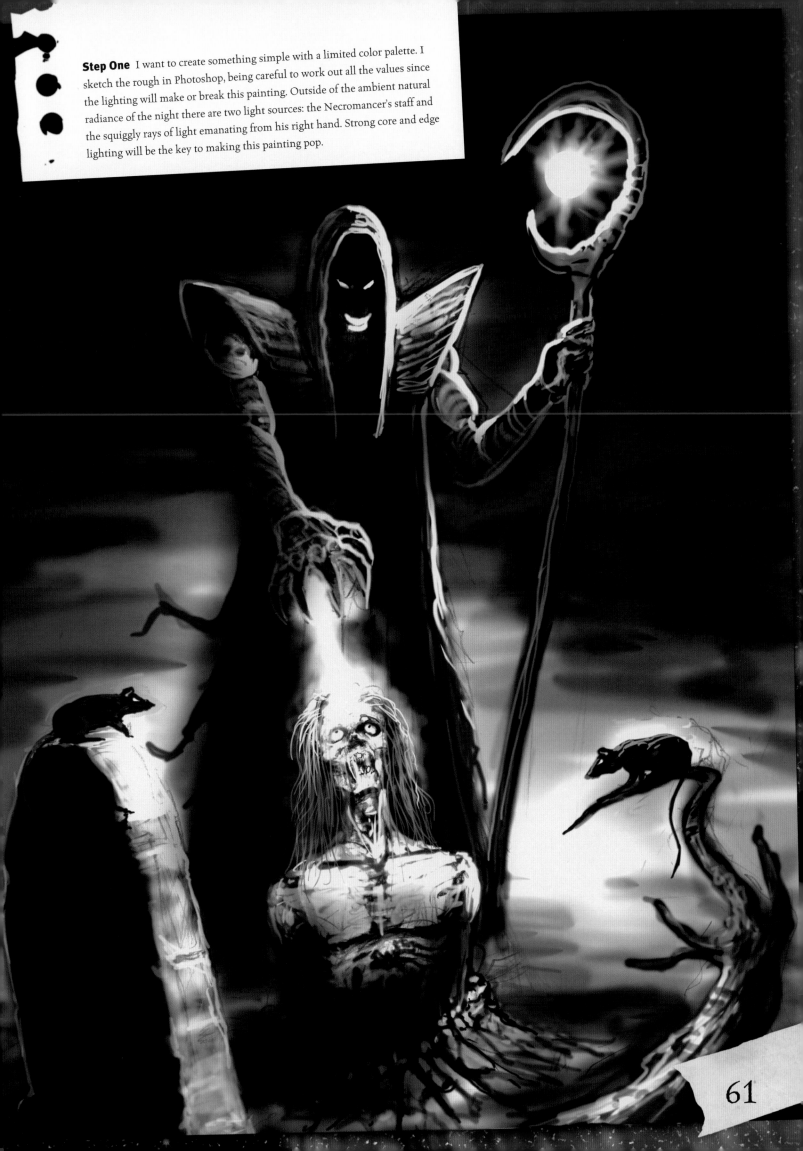

Step One I want to create something simple with a limited color palette. I sketch the rough in Photoshop, being careful to work out all the values since the lighting will make or break this painting. Outside of the ambient natural radiance of the night there are two light sources: the Necromancer's staff and the squiggly rays of light emanating from his right hand. Strong core and edge lighting will be the key to making this painting pop.

61

Step Two Because of acrylic's opacity, I can't lay down a detailed outline until the background is finished. The best way to create smooth graduations quickly in acrylic is to coat your board or canvas first with a thin layer of gesso. I slightly dilute the colors so they're not too thick and apply them directly on the board. I use a separate brush for each color. I mix in broad strokes of Mars black at the top and bottom, then stroke in cerulean blue and medium magenta in the middle. I'll sometimes use a separate brush to blend the edges of the colors together. Only use gesso in the first layer. If you want it to be even smoother, add a few more layers, thinning your paint with water only.

▶ **Step Three** Next I trace my rough and create the first layer of the Necromancer and the undead using cerulean blue and black. Apart from the teeth, eyes, and the top part of the staff, I avoid using white. I only use white on the top part of the undead character's body to accurately reflect the light source that will be coming from the hand. At this stage, just block in simple shapes—don't get caught up in detail. When painting the skin of the undead I use the watery nature of acrylic to create interesting textures on his rotted skin.

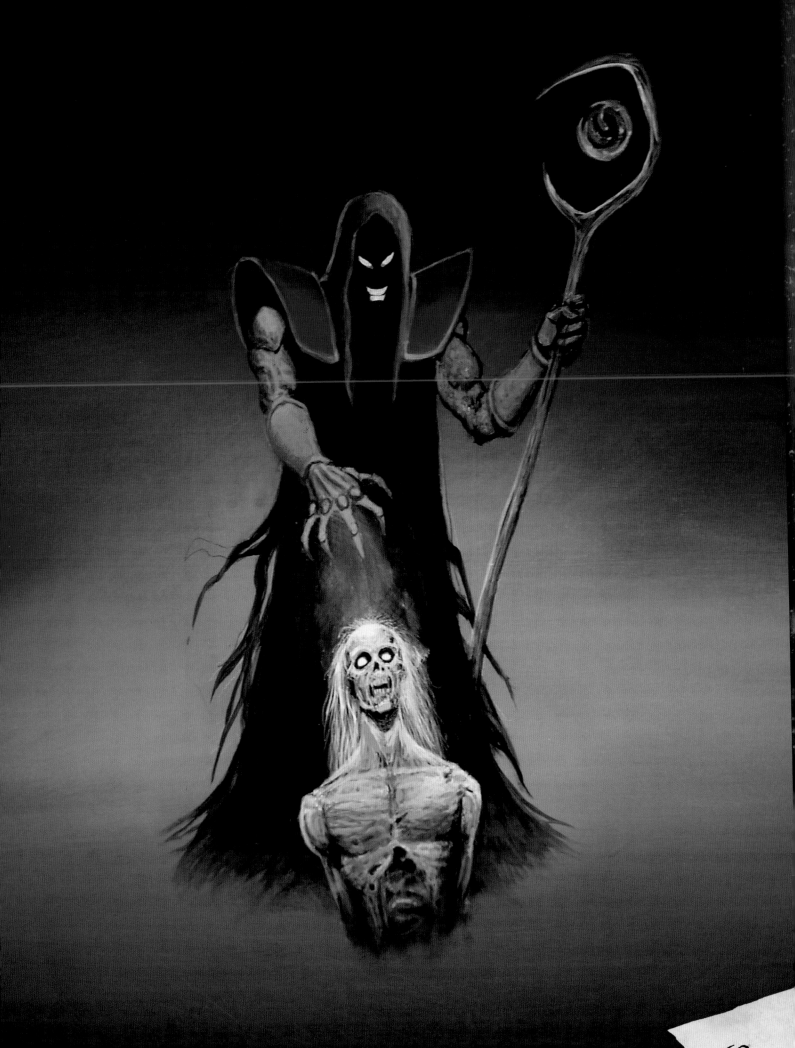

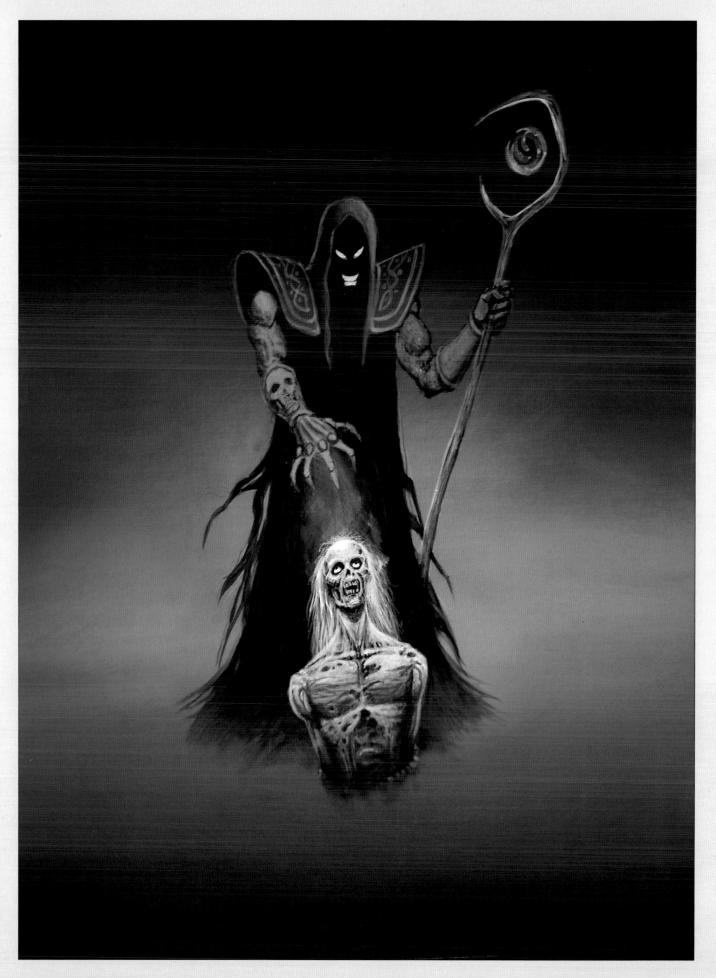

Step Four At this stage I get into more detail. First I add swirling occult patterns to the shoulder pads, and then I add a skull design to the gauntlet. I like the idea of the Necromancer wearing a special magical gauntlet in order to raise the dead. Next I work on the undead, deepening the shadows and adding details to bring out the stringy, decayed muscle and bone. I also add pupils to the eyeballs.

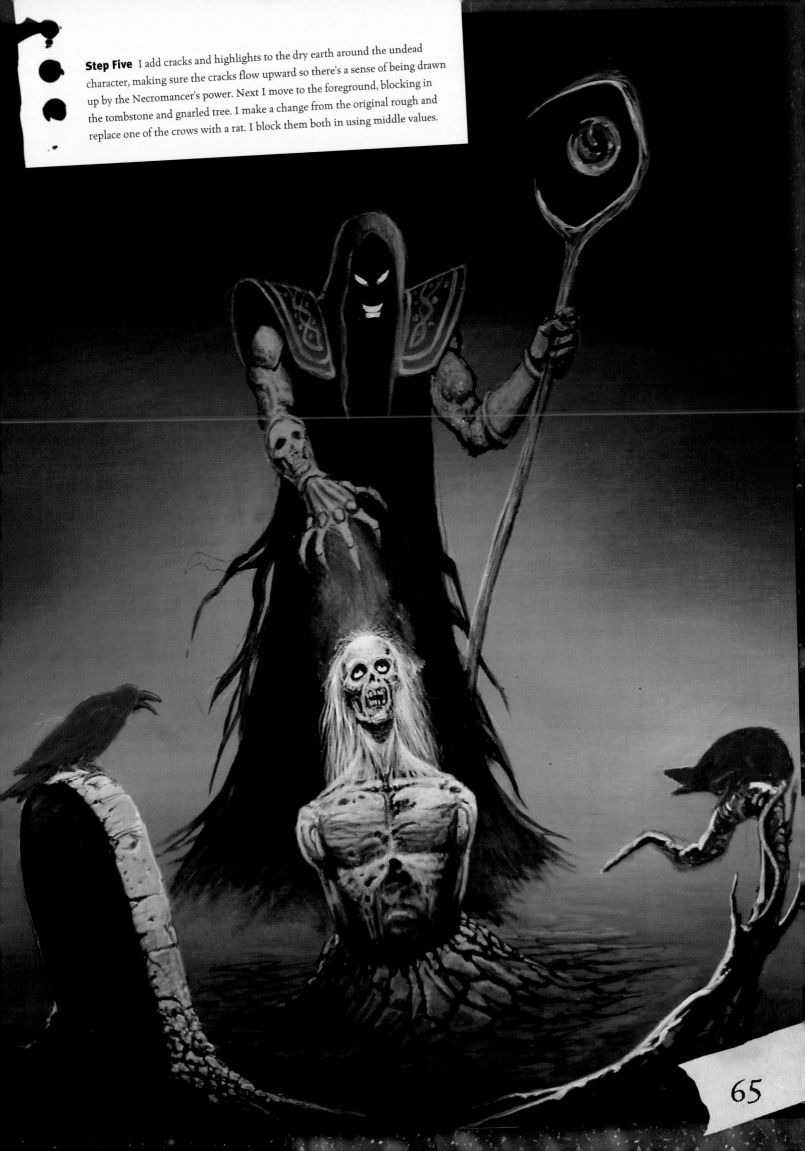

Step Five I add cracks and highlights to the dry earth around the undead character, making sure the cracks flow upward so there's a sense of being drawn up by the Necromancer's power. Next I move to the foreground, blocking in the tombstone and gnarled tree. I make a change from the original rough and replace one of the crows with a rat. I block them both in using middle values.

65

Step Six I add details to the crow's feathers and redden his eye. Then I accentuate the edge lighting on the crow and the tombstone to separate them from the background.

Step Seven The rat and gnarled tree get the same treatment as the crow and tombstone. Make sure the edge lighting is sharp so that they both pop out from the background.

◀ **Step Eight** Now I brighten up the rays coming from the gauntlet and add more. I really want to accentuate the sense of the undead being yanked out of the ground.

▶ **Step Nine** I work on the glowing orb suspended in the crook of the staff and deepen the shadow in front of the undead. I add mist at the base of the Necromancer to blend him more into the background. Finally, I look around the paintings to see where I can heighten the contrast to amplify the spooky lighting and atmosphere as much as possible. Notice how the consistent contrast of blue and magenta helps separate the foreground from the middle ground to add depth.

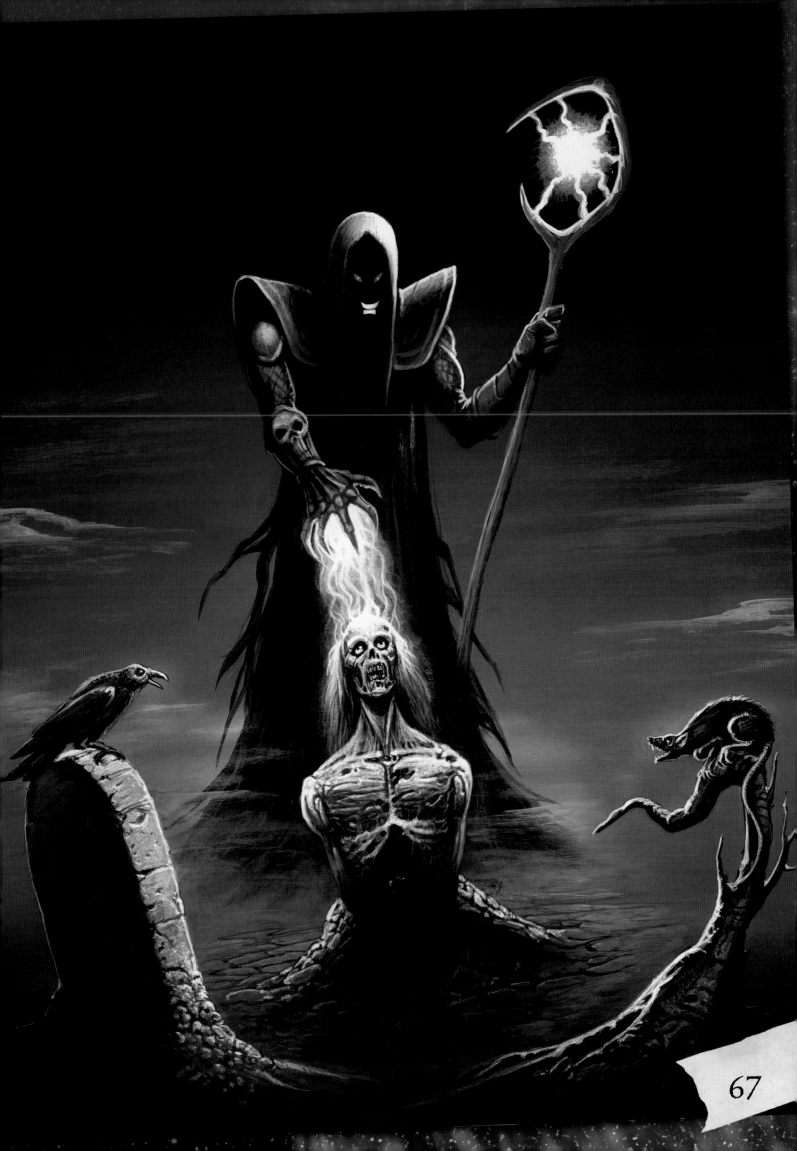

Druid Wizard

One of the oldest and most dynamic examples of a true wizard is the Druid priest of ancient Britain. Druids believed in the power of nature and watched with a keen eye the movements of the sun, moon, and stars. Mostly they believed in a vast pantheon of gods and goddesses and in the realm of the spirits and dreams they called the Otherworld.

Druids raised up massive megaliths of carved rock all over the British Isles long before the coming of the Romans and Christianity. The most famous of these constructions is the giant circle of stones known as Stonehenge. These monuments were used to interpret the seasons and mark the rising and setting of the sun. They also marked power spots and ley lines brimming with spiritual energy.

One of the darker aspects of the Druids' practices was their penchant for human sacrifice to ensure the coming of spring and success in the planting of crops. When crops failed or there were no animals to hunt, the powers of the Druid wizard were seen as crucial to survival in a harsh land.

All of these varied and mysterious aspects went into my choices for creating the Druid wizard. I wanted to create a potent priest of nature, someone physically powerful with a mystical but dangerous stare. After all, controlling the forces of nature and sacrificing your fellow humans is not for the faint of heart.

Palette

This project uses both acrylic and oil paints. A hint of magenta at the top of the painting descends into a muted green in the middle that merges into a warm combination of burnt sienna, red, orange, yellow ochre, and pale yellow. All the colors are designed to make the painting vibrate with strong colors. The careful juxtaposition of muted colors next to more saturated complementary colors creates this effect.

I would like to thank the great and renowned fantasy artist Boris Vallejo, who popularized the techniques I'll be demonstrating in this project. I can still remember the first time I saw one of his paintings on the cover of *The Savage Sword of Conan* many years ago. Then and there I knew I wanted to be a fantasy artist. Vallejo's technique is the one I use in all of my professional work. Once you master the technique, you can complete a painting in less than a week.

Step One First I create small thumbnails with indelible markers. I'm not interested in making detailed figures; I only want to sketch ideas with strong lights and darks. I find that using markers gives me stronger ideas and shapes than using pencil, and it's also much faster. I also like the idea of roughs being disposable. Spending too much time at this stage on a few ideas limits your imagination. I'll sometimes do as many as 20 roughs in marker, with each one taking only a few minutes before I find the one I want.

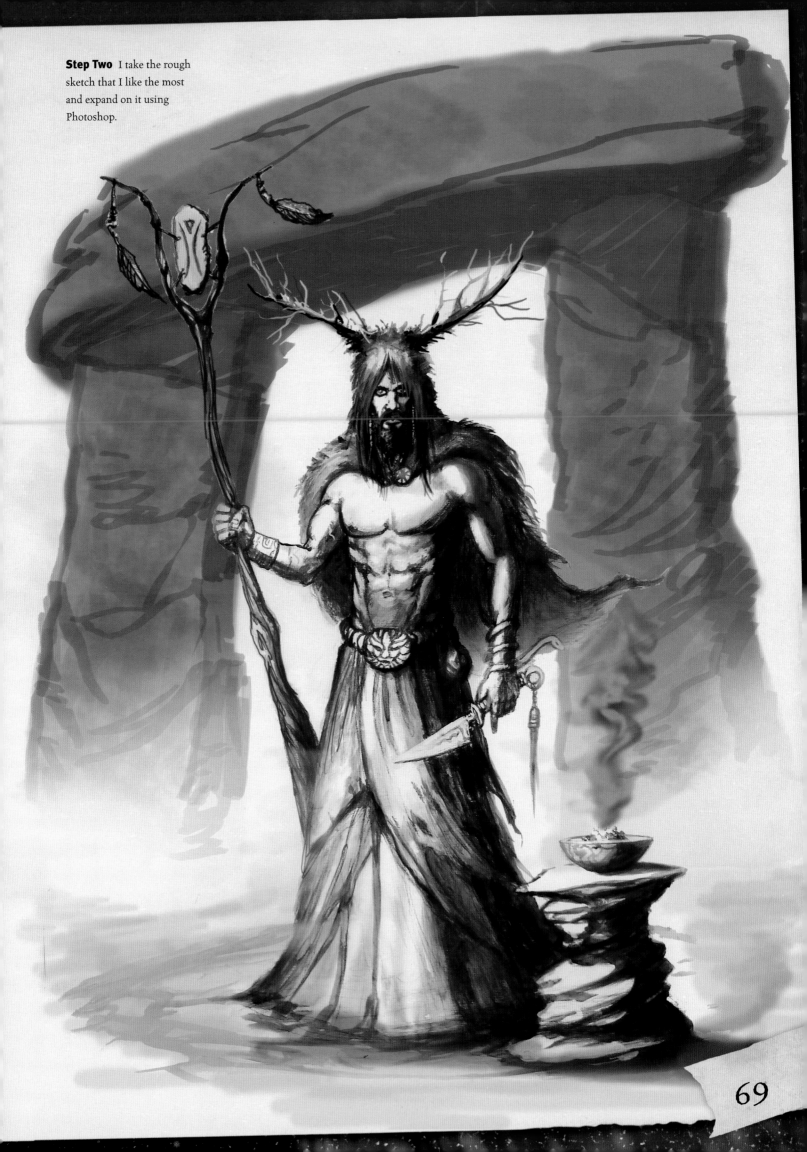

Step Two I take the rough sketch that I like the most and expand on it using Photoshop.

69

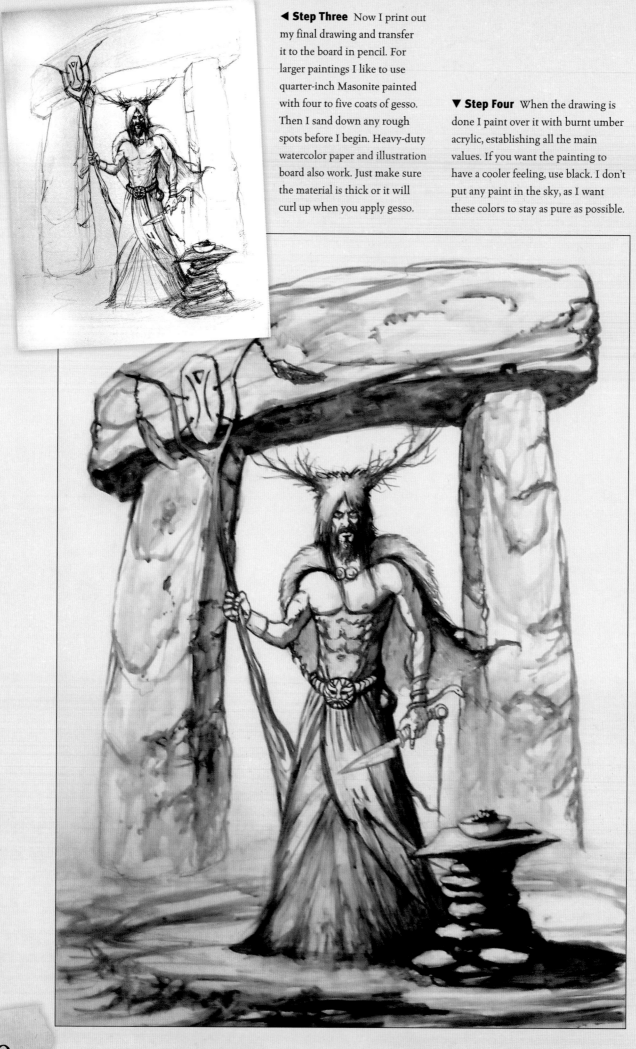

◄ Step Three Now I print out my final drawing and transfer it to the board in pencil. For larger paintings I like to use quarter-inch Masonite painted with four to five coats of gesso. Then I sand down any rough spots before I begin. Heavy-duty watercolor paper and illustration board also work. Just make sure the material is thick or it will curl up when you apply gesso.

▼ Step Four When the drawing is done I paint over it with burnt umber acrylic, establishing all the main values. If you want the painting to have a cooler feeling, use black. I don't put any paint in the sky, as I want these colors to stay as pure as possible.

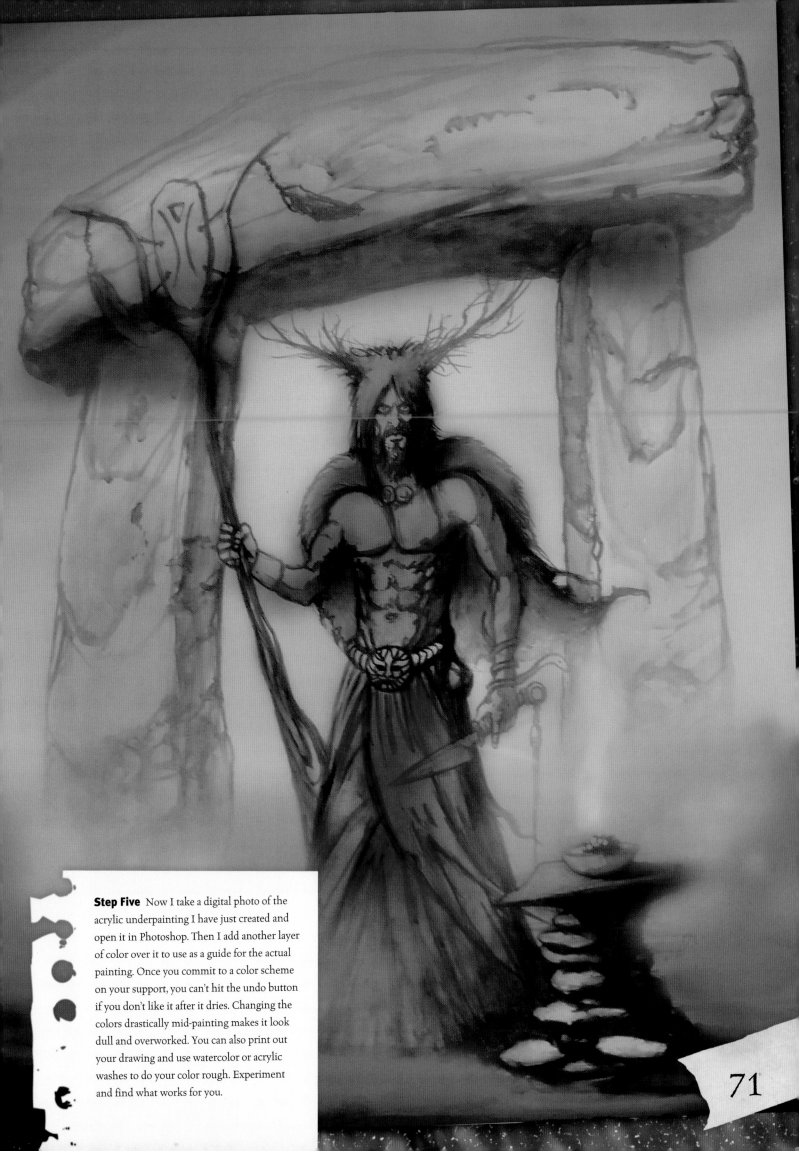

Step Five Now I take a digital photo of the acrylic underpainting I have just created and open it in Photoshop. Then I add another layer of color over it to use as a guide for the actual painting. Once you commit to a color scheme on your support, you can't hit the undo button if you don't like it after it dries. Changing the colors drastically mid-painting makes it look dull and overworked. You can also print out your drawing and use watercolor or acrylic washes to do your color rough. Experiment and find what works for you.

71

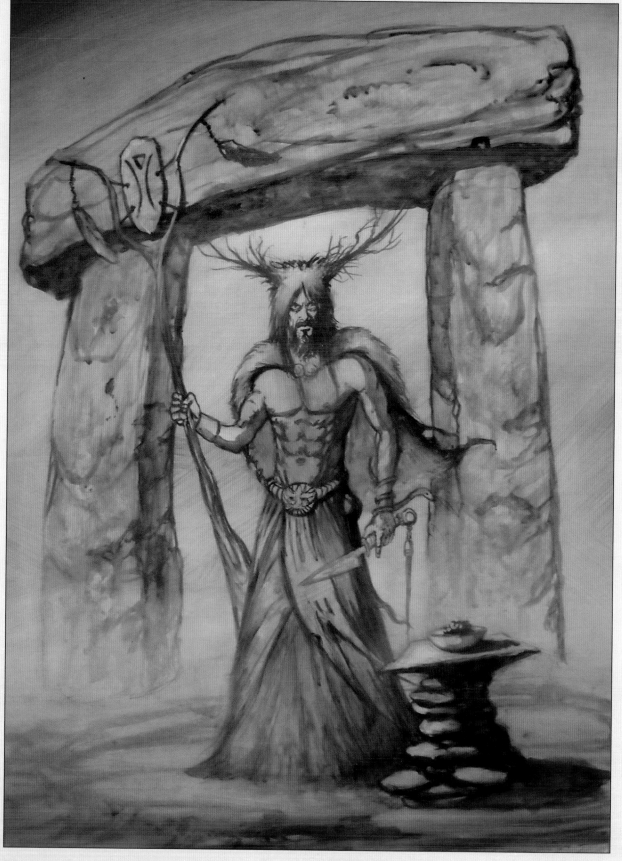

Step Six I mix three quarters odorless paint thinner with about a quarter of cobalt drier, and I lay down the first layer of color using a one- or two-inch brush. The key here is to keep the paint thin and watery. Remember that when working with oils, you are building up color in glazes. It takes about two to three layers minimum to build up a color in oil. The first layer should dry in five to six hours. Make sure the painting is truly dry to the touch before you add a second layer. It's a nightmare if the previous layer starts coming up.

▶ **Step Seven** After the first layer is dry, I add a second layer using Liquin as my medium mixed with a few drops of cobalt drier. This time the paint is a little thicker as I build up color. Don't worry about obscuring the acrylic underpainting. At this stage I try to get the acrylic underpainting done in a few hours in the morning, then put on the first layer of oils mixed with thinner and cobalt drier by noon. I come back before I go to bed and add another layer so it will be dry by morning.

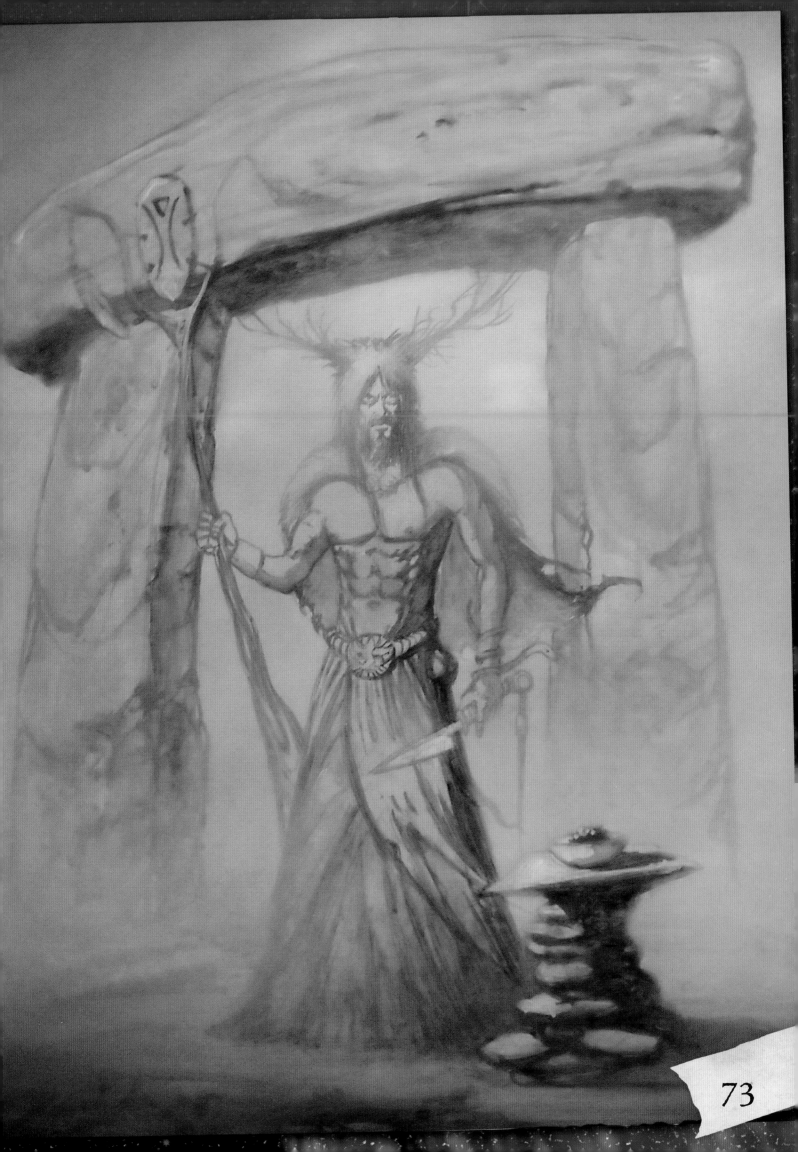

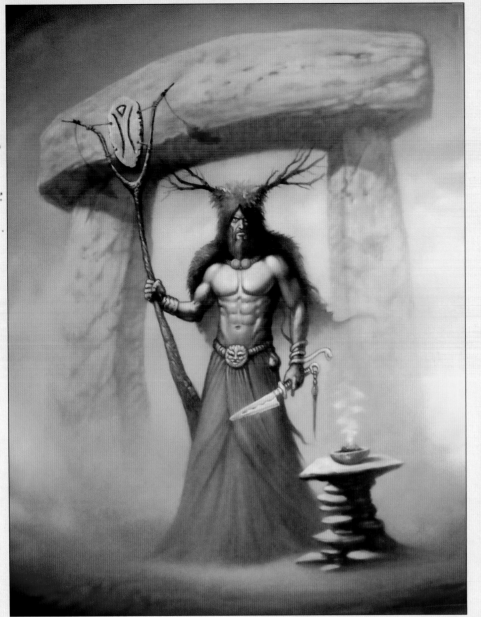

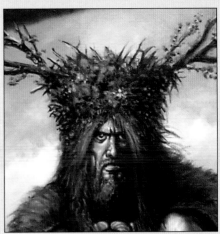

Step Nine Now the time comes to tighten up the details. I add leaves and branches to the headdress and refine the hair. I add blue body paint to the torso and arms. If you look carefully you'll notice the consistent contrast of warm and cool colors. This careful arrangement of contrasting color and design is what makes a painting really pop.

Step Eight I start painting the background, working from back to front. I mute down and darken the sky and then begin rendering the stone arch, keeping the colors warm against the cooler sky. I pump up the foreground mist and then start the figure. The most important aspect of this technique is that the edges of the painting and the base of the figure should be fogged out and blurred. This gives the feeling of a figure emerging from the mist—a moody, fantastical effect perfectly suited for this kind of painting. It also creates a sense of movement even when the figure is standing still. Everything else is painted in sharp focus. Our eye naturally goes to the spot with the highest detail and contrast.

Step Ten I brush in overlapping layers of yellow and white smoke. I stroke them in thinly at first and then gently blur them with a larger brush. In the foreground, I brush green and blue into the earth to balance out the painting and create overall color harmony. Then I add some white around the head to heighten the contrast.

Druid Detail

Here the cool blue of the body paint and the snake contrasts with the warm skin tone.

The bluish snake wrapped around his wrist is cool against the warm yellow and orange.

The knife is cool against the warm dress and breechcloth.

The feathers on the staff contrast with the warm background.

74

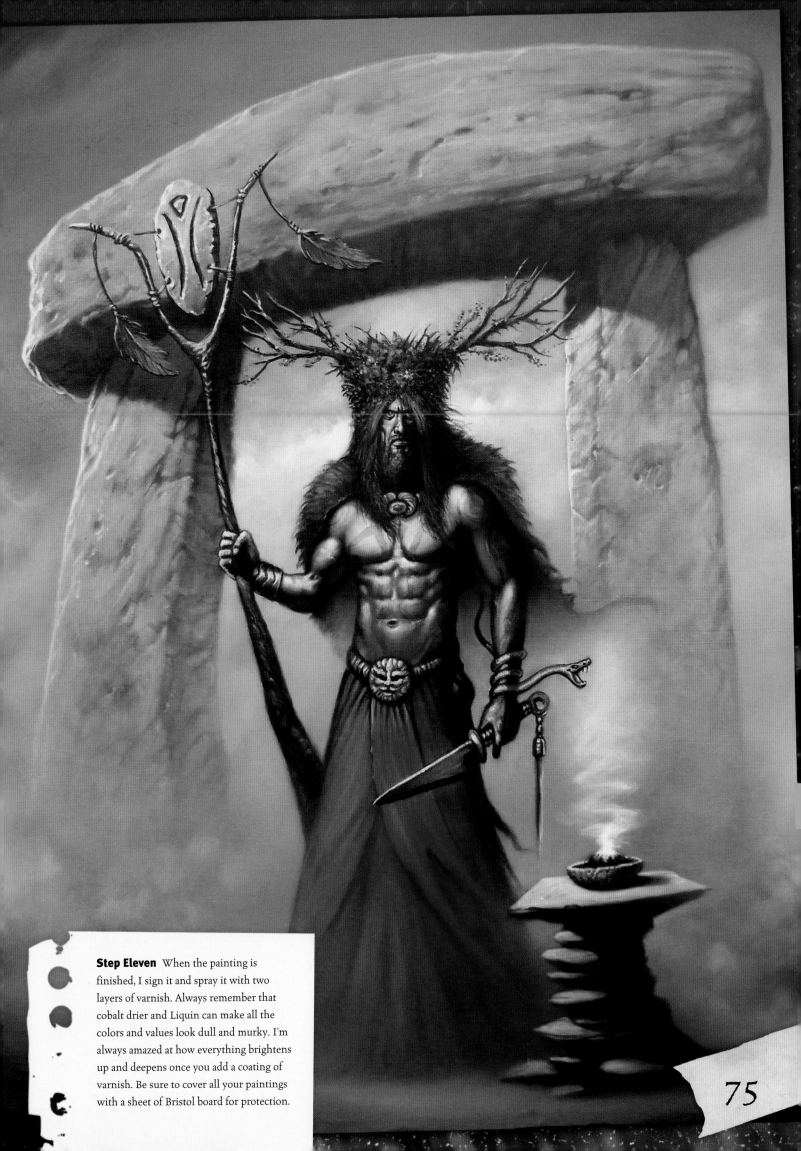

Step Eleven When the painting is finished, I sign it and spray it with two layers of varnish. Always remember that cobalt drier and Liquin can make all the colors and values look dull and murky. I'm always amazed at how everything brightens up and deepens once you add a coating of varnish. Be sure to cover all your paintings with a sheet of Bristol board for protection.

Chapter 4:
Introduction to
Digital Illustration

Y ou might think there's a big gulf between drawing and painting and digital illustration, but that isn't the case. The techniques I use in Photoshop aren't much different than those I use on canvas. After all, color is color, and values are values. If you're new to digital art, don't over-complicate the process.

For the sake of simplicity, I'll only be using Photoshop CS and a Wacom® Tablet for the projects in this book. The only other things you'll need are a good-sized monitor, a fast computer, and a graphic-friendly video card.

When first using a Wacom Tablet it can feel very strange and awkward, but it'll feel completely natural with time. Because Wacoms are pressure-sensitive, much of your style of rendering will depend on the subtle use of your pen. The opacity of your lines is determined by two factors: the brush opacity and the amount of pressure you put on the pen. You'll soon find a balance between the two.

Every artist eventually develops his or her own way of doing things, especially in Photoshop, as there are many different ways to achieve the same effect. The best advice I can give an artist who is new to digital painting is to experiment. Nothing is written in stone. If you're not sure what a filter or a brush does, try it out and see where it takes you. You have nothing to lose. But remember that Photoshop is only a tool; it can't create the painting for you.

The tools I'll be using repeatedly are the brush and pencil, with the opacity adjusted to various levels. I use low opacity for transparent washes that you can build up and high opacity for a more opaque rendering. Also check out the hardness and softness settings for each brush. For example, a soft brush will give your painting a fuzzy, soft-focus look. For sharper detail and stronger edges, use a harder brush. I also like to use the Dodge and Burn tools, especially for finishing touches and adding contrast. To alternate between them, use the Alt key.

Remember that your most important tools are not the tools in Photoshop but your own powers of observation. In the end, all artistic skill is simply learning to see things differently.

Digital Illustration Materials

New artists are often mysti-
fied by digital art tools, but
a computer is not magic. It will
not explode if you hit the wrong
button. I remember being terri-
fied of my PC when I first made
the switch from traditional medi-
ums to digital. Mission control at
NASA looked less complicated.

In addition to a fast computer, a
Wacom® Tablet, a good-sized monitor,
and a quality video card are crucial to
successfully painting with software
like Photoshop. You'll also need at
least a gig of RAM. Always save your
work in more than one place (you'll
thank me later).

Without mastering your Wacom
Tablet, creating sophisticated
paintings is next to impossible. A
mouse is simply not sufficient for the
necessary subtle gradations and line
work. Remember that you are the one
in control, not your computer. It does
what you tell it to do (most of the
time). It's a master/slave relationship
where occasionally, against our
will, the slave rebels. That's why the
mantra of all experienced digital
artists is "save often."

Wacom Tablet The most important tool is the Wacom Tablet. Mine is 6" x 8", but you can get
smaller tablets. I know many artists who prefer smaller ones, especially if they use laptops and
don't want to cart around a big tablet. I don't like to go larger as I find it wears my hand out. Be
sure to experiment with the settings to get the right amount of pressure sensitivity. Every artist has
a different touch.

Monitor The size of your monitor should depend on the size and orientation of the painting you'll
be creating. If you'll mostly be creating high-resolution movie posters or huge sci-fi spacescapes, a
wide monitor will be best for you. Because most of the work I'm doing for this book is vertical, I
prefer to use an average 22-inch monitor.

◄ Printer with Scanner Many printers come with a scanner, but you can buy them separately as well. When working digitally, I sketch the drawing on paper, scan it, and then open it and work on it in Photoshop. I recommend printing out your finished digital paintings on glossy paper, as this will help you see any mistakes you may have missed when viewing your work only on your monitor.

► Separate Scanner If you want to buy a scanner separately, I recommend the Canon® brand. I've owned several over the years, and they've lasted well past their warranty. Scanners do have a tendency to wear out, especially if you use them a lot. For that reason alone I like to have a backup.

▼ Digital Camera A digital camera is an absolute necessity and not just for taking nice pictures of your family and friends. I like to go out on texture hunts, searching for cool and interesting objects (both natural and manmade) to photograph, most of them very close up.

Building up a library of texture resources is one of the most important things a serious digital artist can do, as the Internet can only help you so much. It's nice to go out and find things that can make your work truly original and not derivative. This is especially true if you work as a texture artist in the video game industry.

79

Dark Sorceress

The Sorceress is the bad girl of the magical fantasy world, frightening in her evil as well as her beauty. Steeped in the darkest and most seductive aspects of the dark arts, she's used her powers since the dawn of history to seduce and trick unwary adventurers and steal their souls' energy for herself. She follows in the ancient Greek tradition of Circe and Medea, the worshippers of the goddess Hecate, made famous in Homer's The Odyssey and The Iliad. More recent incarnations include Morgan Le Fey, the beautiful sorceress who ensnared King Arthur and his knights, and even Merlin.

Many fools and wise men have been lured to their doom and everlasting despair by the charms and spells of the Sorceress. Few have ever escaped her clutches and when they do, they rarely leave with their minds intact. With souls and faculties addled and crazed, they sit wide-eyed in dank corners waiting for her demonic beasts to drag them down to greater horrors than they have ever known. There's no escape from the Sorceress.

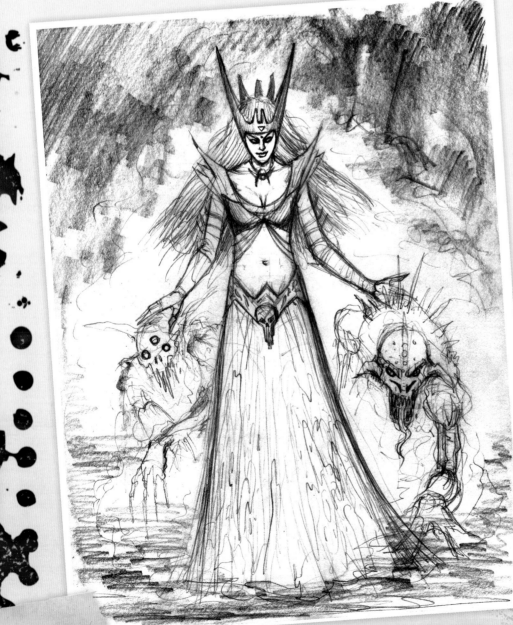

◀ Step One I decide on a simple triangular composition, featuring the Sorceress and two demons she has summoned. I scan the rough at 400 dpi. Then in Photoshop, I create new layers for each element: the background, each demon, and the Sorceress. Don't forget to label your layers, as this will help avoid confusion later. I'll probably have about 20 layers by the time I'm finished.

▶ Step Two I start on the background using large brushes to fill it in quickly. I use a dark color palette consisting of black, a range of blue, reddish-brown, and violet.

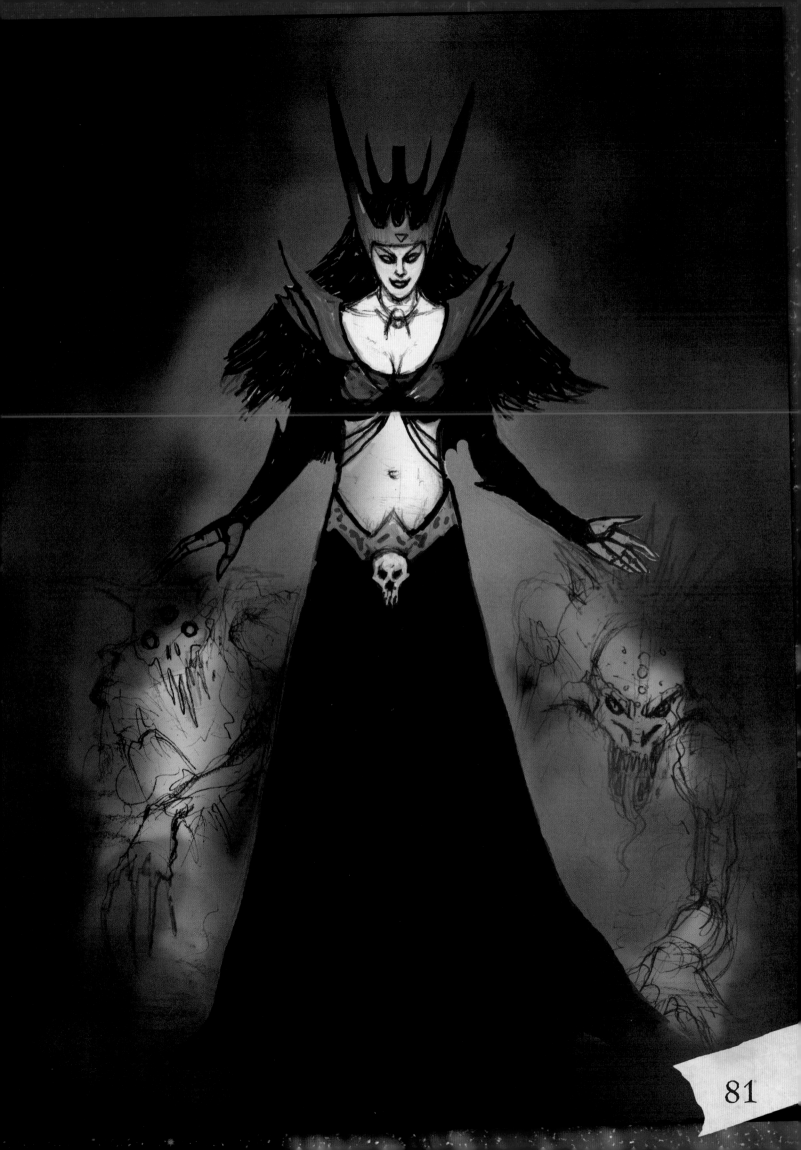

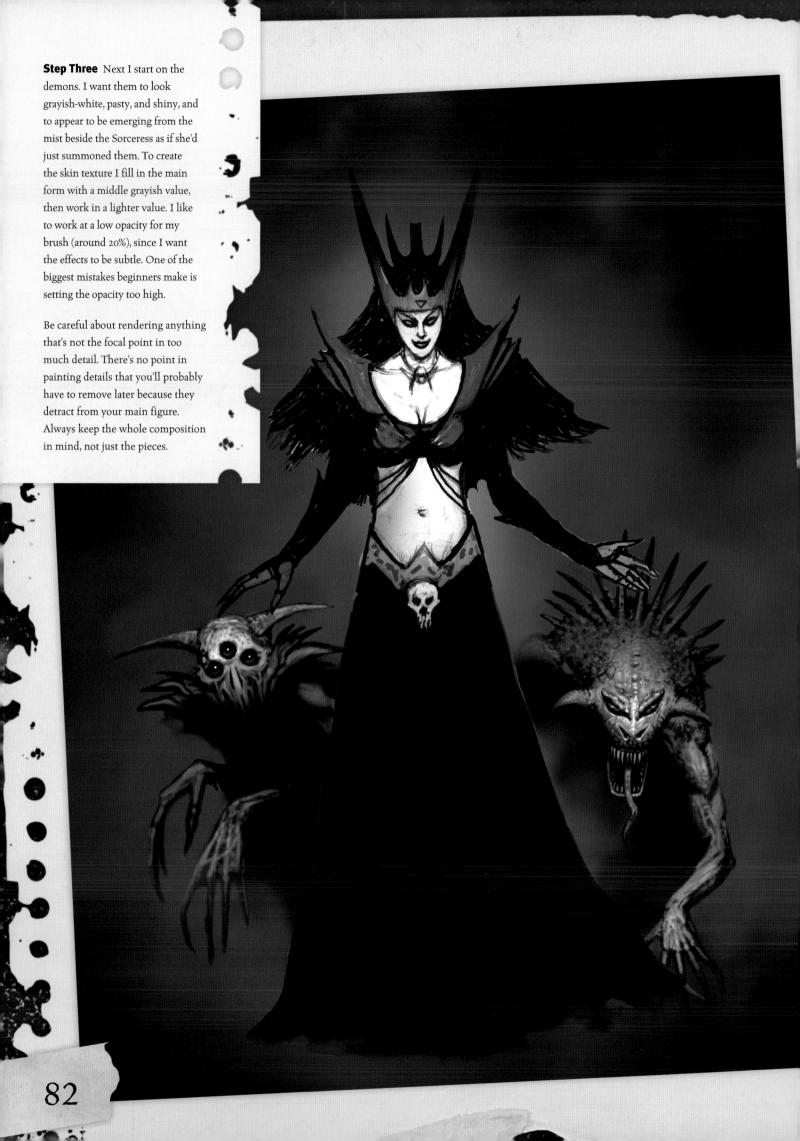

Step Three Next I start on the demons. I want them to look grayish-white, pasty, and shiny, and to appear to be emerging from the mist beside the Sorceress as if she'd just summoned them. To create the skin texture I fill in the main form with a middle grayish value, then work in a lighter value. I like to work at a low opacity for my brush (around 20%), since I want the effects to be subtle. One of the biggest mistakes beginners make is setting the opacity too high.

Be careful about rendering anything that's not the focal point in too much detail. There's no point in painting details that you'll probably have to remove later because they detract from your main figure. Always keep the whole composition in mind, not just the pieces.

82

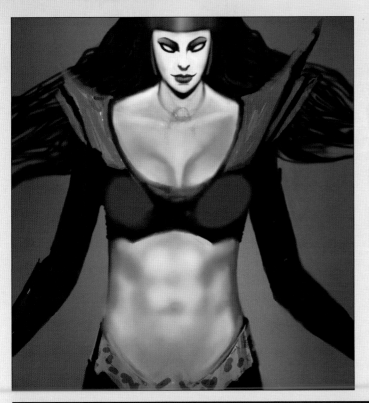

◄ Step Four Now I move to the dark queen herself. First I focus on her skin, which I want to keep pale but warm in spots—just pale enough so she'll contrast nicely with the predominantly cool background around her. She's not undead—just very evil.

Hair Detail Using long, smooth strokes with a 10px brush, I create her hair on a new layer behind her. I use the Smudge tool set at 50% to blur her hair and give it a more sinuous look and a sense of movement. I follow the direction of her hair, almost like I'm brushing it.

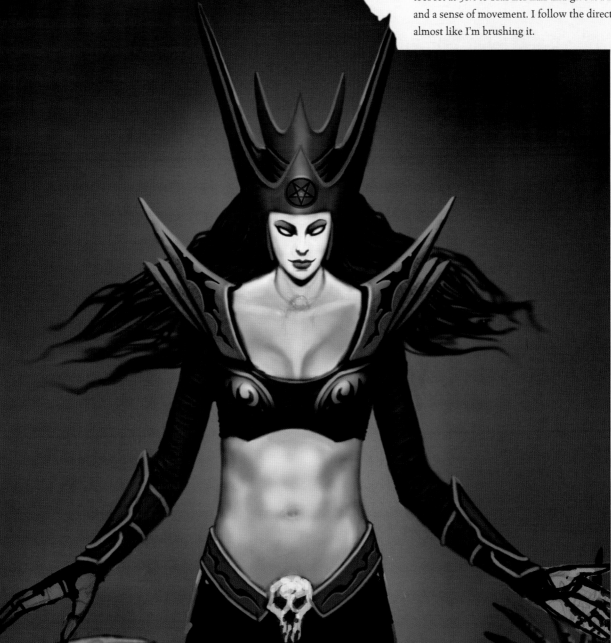

◄ Step Five
Next I move to her clothes. Working with my grayish-blue palette, I render her headpiece and add an upside-down red pentacle to finish it off.

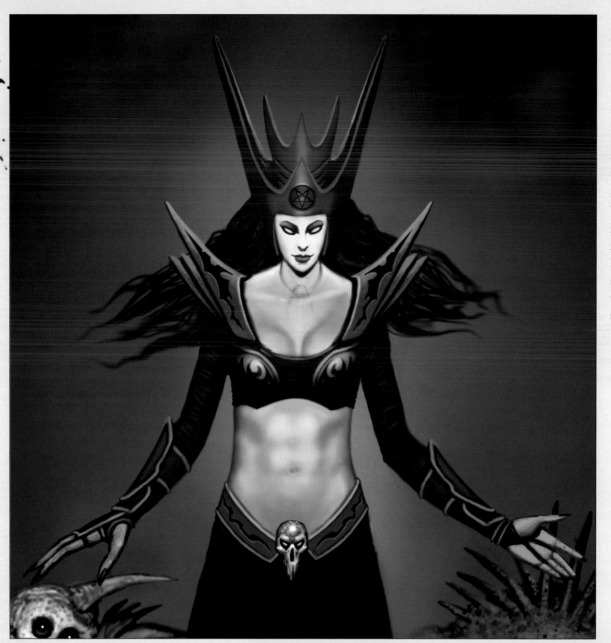

Step Six Moving down to the shoulder pads, I render one of them in detail; then I copy and paste it, flip it horizontally, and place it on the other shoulder. I repeat these steps for the belt as well and add a metallic skull for a buckle. I do the same for the bucklers on the forearms. When you have a figure that is symmetrical in parts, this is a good way to save yourself time.

Step Seven Working on the dress, I add thin, veinlike lines of muted crimson flowing upwards toward the waist to give the black some texture. I also make the hem ragged (see final step).

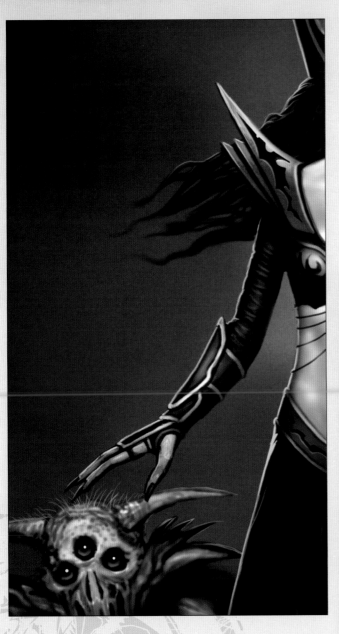

Step Nine When I get near the end of a painting, I start to flatten the layers, of which there are now five. The background is on the first layer, and each demon has its own layer. I make sure that the hand of the demon on the right moves into the foreground to give the picture more depth.

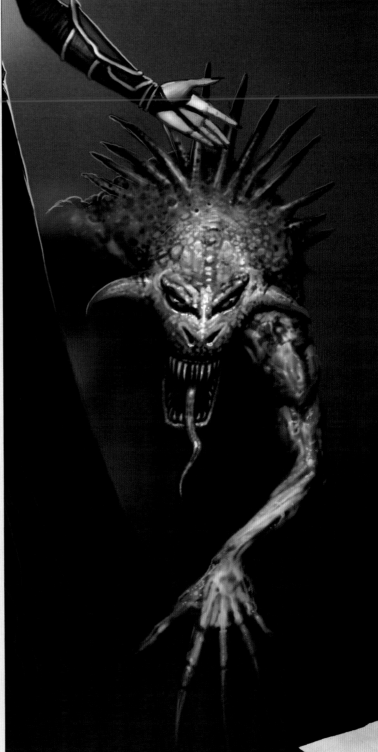

85

Step Ten I realize that I need some kind of foreground so the Sorceress doesn't look like she's floating. I add a cracked-earth texture, making this the first layer, and tilt it backward using the Perspective and Scale tools.

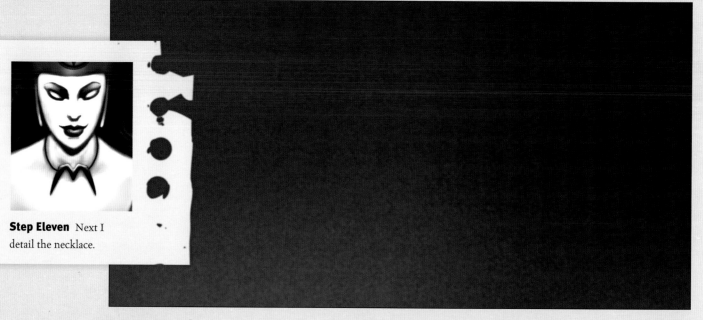

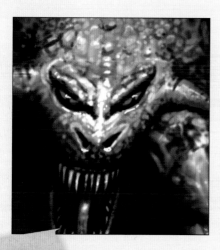

Step Eleven Next I detail the necklace.

Step Twelve Now I make final adjustments to the background and the foreground mist. When using washes of color, I add a bit of visual "noise" to the layer, which helps get rid of any banding and gives the background a more interesting texture. One thing I don't like about most digital art is that it's too smooth and vacant of texture. Too much of it looks the same because it lacks the personalized character that real paint offers.

▶ **Step Thirteen** Now I get to work with the Burn and Dodge tools set at about 30%, looking for areas where I can darken shadows and add highlights. Don't overuse this tool or you'll end up losing a lot of your middle values. Finally, the Sorceress is finished. Look upon her terrible beauty and be afraid.

Dark Sorceress Details

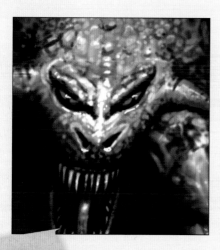
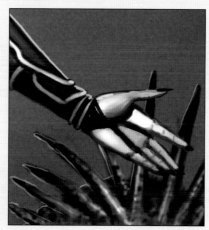

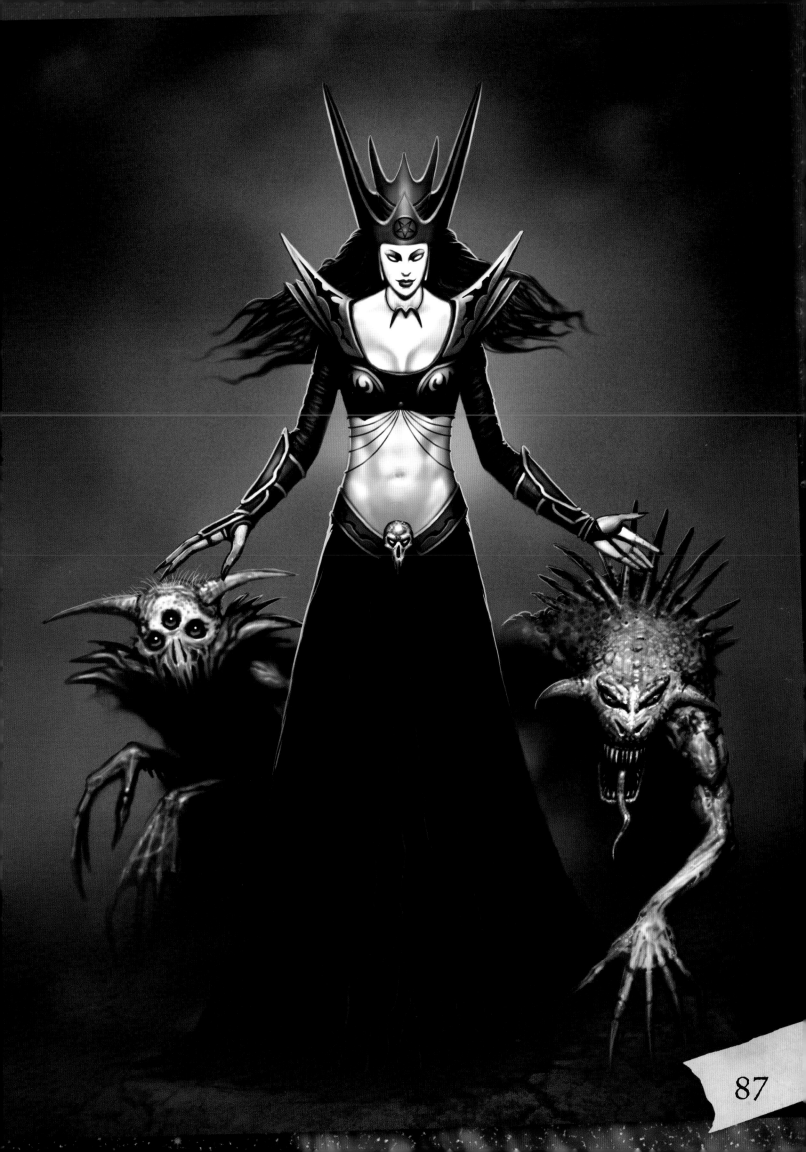

Alchemist

The Alchemist is the wizard as a mystical scientist. He spends his time searching through arcane books filled with cosmic symbolism and ancient languages. Long into the night his hungry eyes scour dusty grimoire after grimoire for the hidden blueprints of the universe that will reveal the secret of life and immortality.

The origins of Western alchemy are traceable back to ancient Egypt, with later influences from China and Persia. The quest for the Materia Prima, or the Philosopher's Stone, has always been the main desire of the dedicated alchemist. This is the shimmering rainbow that bridged the chasm between the earthly and the heavenly, the vast gulf between matter and spirit.

Some alchemists seek to thwart time and discover the secret of immortality. It is said that some even found it and distilled it down to a precious elixir that any man would kill for. Unfortunately for the Alchemist, even if he is immortal he is not immune to being murdered. It is also rumored that many alchemists met such unfortunate ends as thieves sought to steal their most prized secrets and formulas.

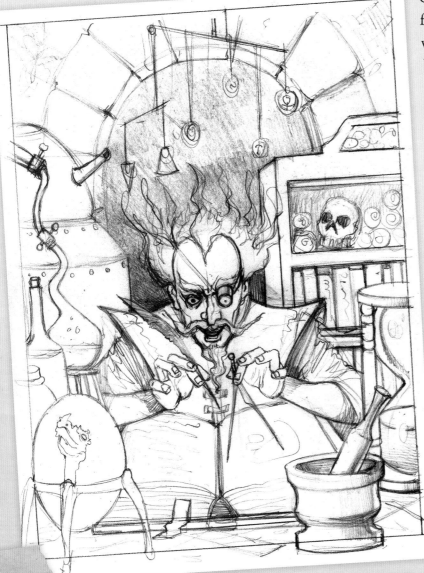

Others looked at alchemists as kooks and frauds who lured the gullible and ignorant with promises of limitless gold made from base metals. Most alchemists were simply wise, clever wizards searching for the golden keys that would unlock the sacred mysteries of life and death.

◀ **Step One** The Alchemist is the most complicated of all the projects in this book, so I need the rough to be fairly detailed. First I scan in a pencil rough, and then I open it in Photoshop and add to it using the Airbrush tool.

▶ **Step Two** I like the idea of the Alchemist as a mad scientist/wizard on the verge of a great discovery. Behind him to the left is a furnace where all sorts of chemical concoctions are baked for long periods. To the right is a bookcase filled with scrolls, bottles, a skull, and a hand pointing towards heaven. He also has a grimoire to write down and decipher mystical diagrams, and I also throw in an hourglass, mortar and pestle, more bottles, a beaker, and a dragon's egg.

Next I cut up the rough into several layers: The background is on the first layer; the furnace and bookcase are on the next layer; the Alchemist is on the third layer; the grimoire is on the fourth; the bottles and the beaker are on the fifth; the hourglass and pestle are on the sixth; and the dragon egg is on the seventh.

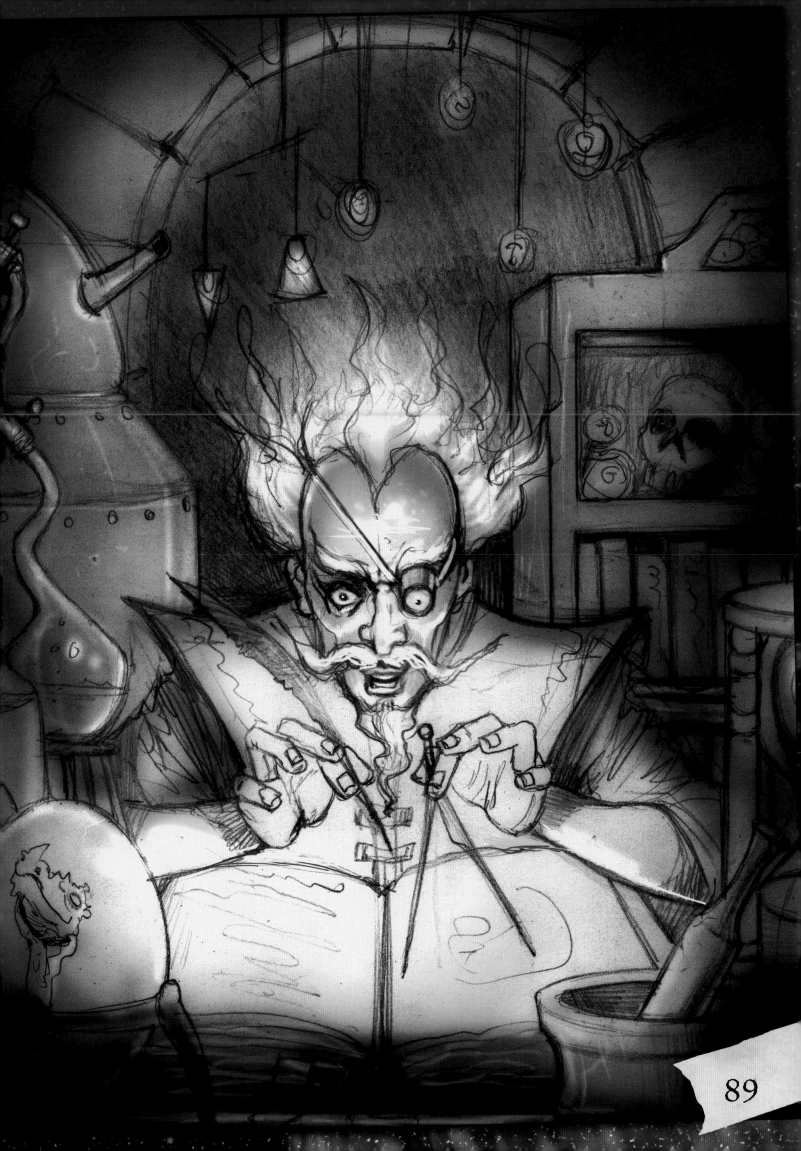

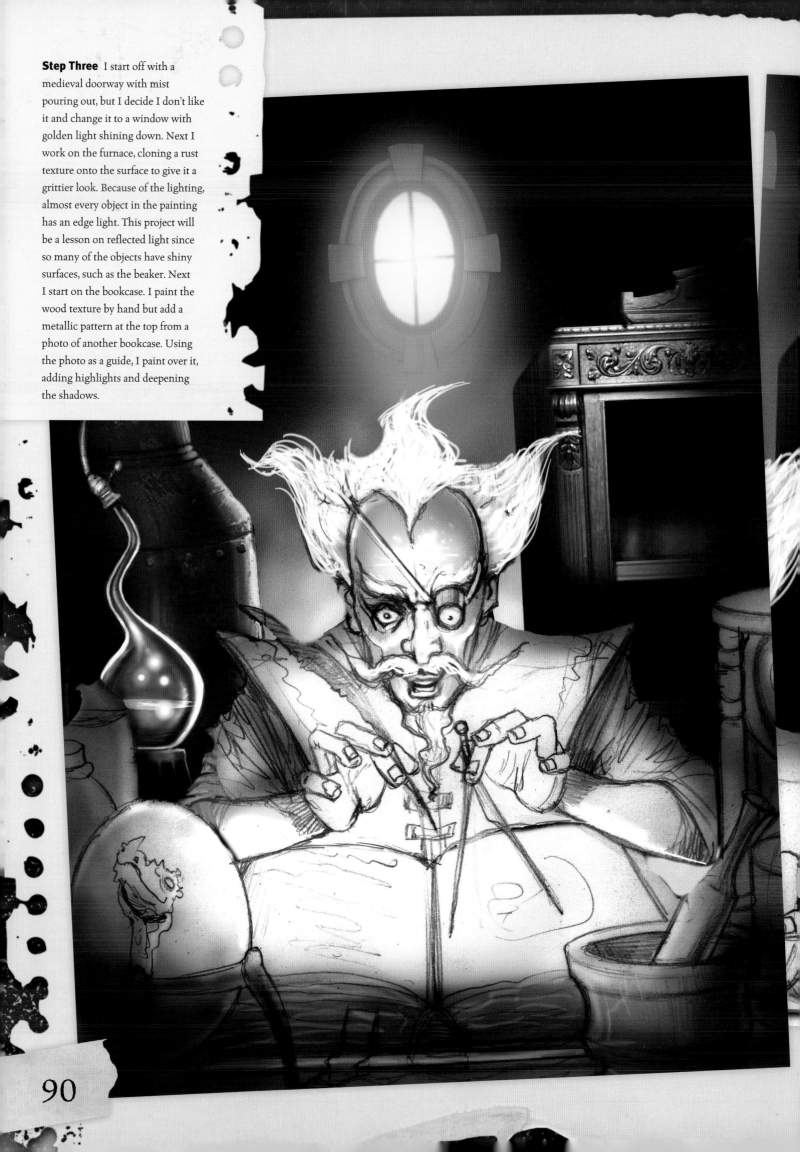

Step Three I start off with a medieval doorway with mist pouring out, but I decide I don't like it and change it to a window with golden light shining down. Next I work on the furnace, cloning a rust texture onto the surface to give it a grittier look. Because of the lighting, almost every object in the painting has an edge light. This project will be a lesson on reflected light since so many of the objects have shiny surfaces, such as the beaker. Next I start on the bookcase. I paint the wood texture by hand but add a metallic pattern at the top from a photo of another bookcase. Using the photo as a guide, I paint over it, adding highlights and deepening the shadows.

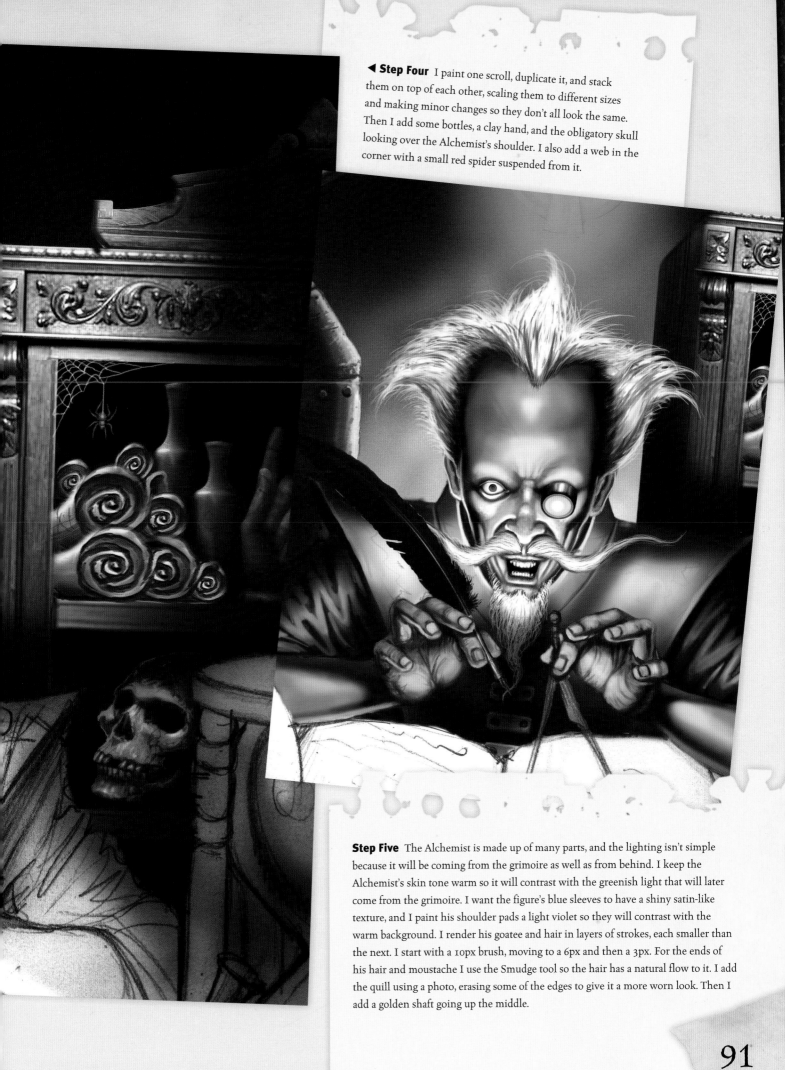

◄ Step Four I paint one scroll, duplicate it, and stack them on top of each other, scaling them to different sizes and making minor changes so they don't all look the same. Then I add some bottles, a clay hand, and the obligatory skull looking over the Alchemist's shoulder. I also add a web in the corner with a small red spider suspended from it.

Step Five The Alchemist is made up of many parts, and the lighting isn't simple because it will be coming from the grimoire as well as from behind. I keep the Alchemist's skin tone warm so it will contrast with the greenish light that will later come from the grimoire. I want the figure's blue sleeves to have a shiny satin-like texture, and I paint his shoulder pads a light violet so they will contrast with the warm background. I render his goatee and hair in layers of strokes, each smaller than the next. I start with a 10px brush, moving to a 6px and then a 3px. For the ends of his hair and moustache I use the Smudge tool so the hair has a natural flow to it. I add the quill using a photo, erasing some of the edges to give it a more worn look. Then I add a golden shaft going up the middle.

91

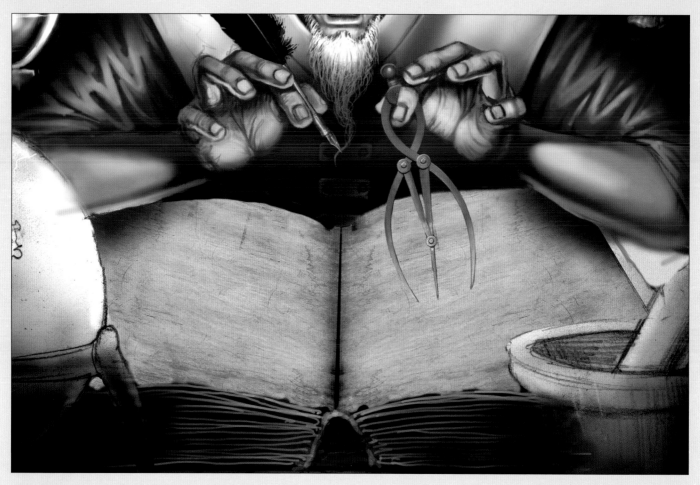

Step Six For the grimoire, first I lay down some parchment textures for each page, burning the edges a little to make them look older. Using long strokes at about 7px, I paint the pages beneath and use the Burn and Dodge tools to give them a rougher appearance. Then I place a caliper between the Alchemist's fingers.

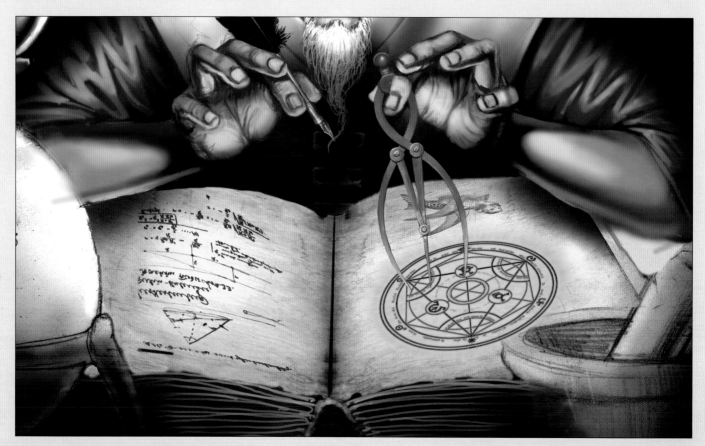

Step Seven I add the circular diagram and the writing on a separate layer, scaling them down to fit the page by using the Scale and Perspective tools. Then I add a lime green glow around the diagram.

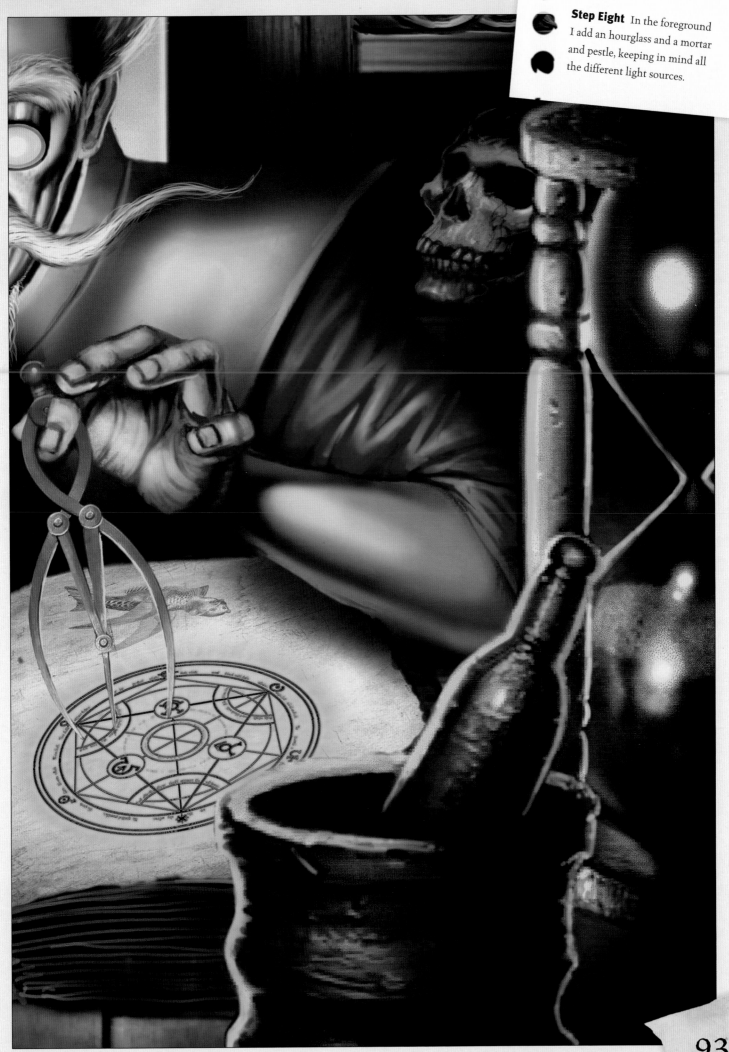

Step Eight In the foreground I add an hourglass and a mortar and pestle, keeping in mind all the different light sources.

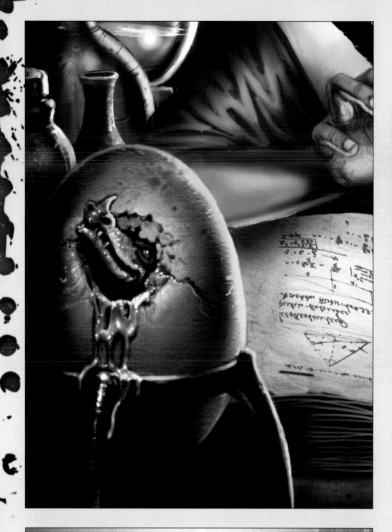

◄ Step Nine Next I add another foreground piece, the dragon's egg, using a warm orange and strong edge lighting so it will advance more. Then I use the filter Craquelure (under Texture) to add a bit of texture to the egg.

▲ Step Ten The final touches in this painting are very important. Starting in the background, I add a layer of airbrushed golden light, blur it slightly, and place it over the furnace and bookcase, making them recede more into the distance.

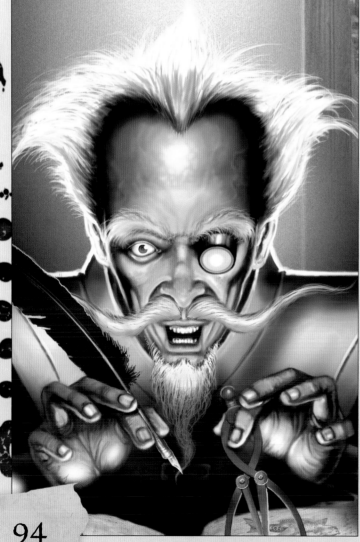

◄ Step Eleven Now I add edge lighting around the Alchemist and his sleeves, and then I finish his bushy eyebrows. I do the same for the quill and even the caliper. Using the Burn and Dodge tools, I look for areas where I can add or brighten up a highlight or deepen a shadow, such as under his forearms. On the top layer, I airbrush light lime green on the Alchemist's face, goatee, and palms. I play with the opacity so the light won't look too opaque. I also add veins and a more mottled texture to his forehead. Next I deepen the shadows around the monocle. Finally, I add a touch of green along the edge of the dragon's egg, the mortar and pestle, and other areas where the light of the glowing diagram might shine.

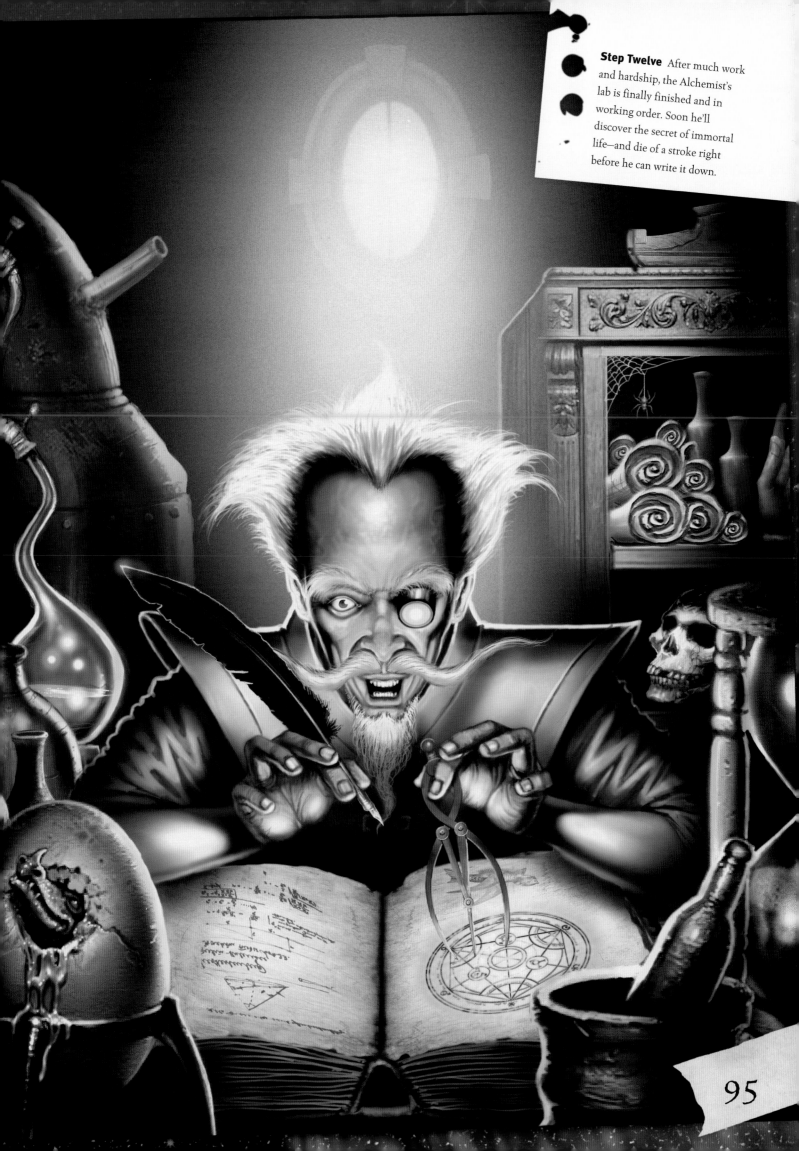

95

Enchantress

The beautiful Enchantress is the foil of the Sorceress; she's the Glinda to the Wicked Witch of the West. In many ways she represents the power of white magic at work in the world. During medieval times she often appeared to lost travelers and was sought out by knights on quests, who beseeched her assistance.

Only those of noble and kind hearts could find her. While the dark Sorceress seeks to steal your soul and enslave you, the Enchantress points the way to freedom. But even the Enchantress's blessings come with a price: Whatever tasks she discharges you to complete must be fulfilled at all costs.

An aura of powerful magic and light surrounds the Enchantress. Her lips are curved in a benevolent smile; her hands are raised in greeting; her eyes are bright with sacred knowledge and clarity. Fortunate indeed is the wayfarer whose path is blessed by the Enchantress.

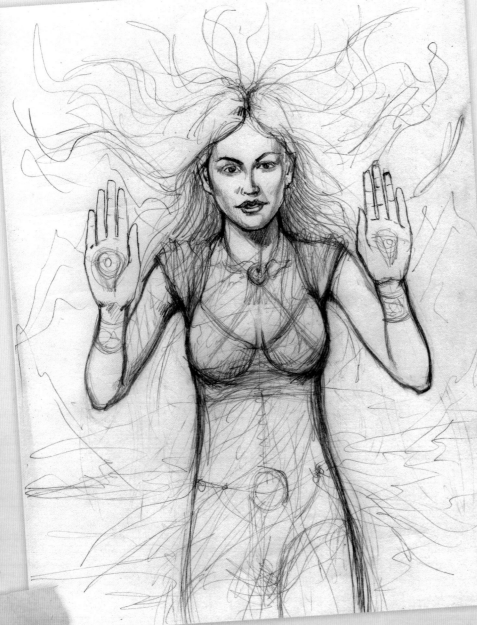

◄ **Step One** There's a strong link between the benevolent goddess figure and the Enchantress, so I envision in my rough a cross between the two. Maybe good Enchantresses get to become goddesses someday. I sketch a beautiful Nordic Enchantress who abides in the mountains, imagining that one of her abilities is to manipulate the winds. I sprinkle her with elegant jewelry and abundant flowing hair.

▶ **Step Two** Working in Photoshop, I use a collage of different photos to create a background of mountains shrouded by mist. In this particular project I'll be using more photos and textures than I normally would. You don't have to hand-paint everything; the trick is knowing how to manipulate photos and even paint over them so they blend in naturally.

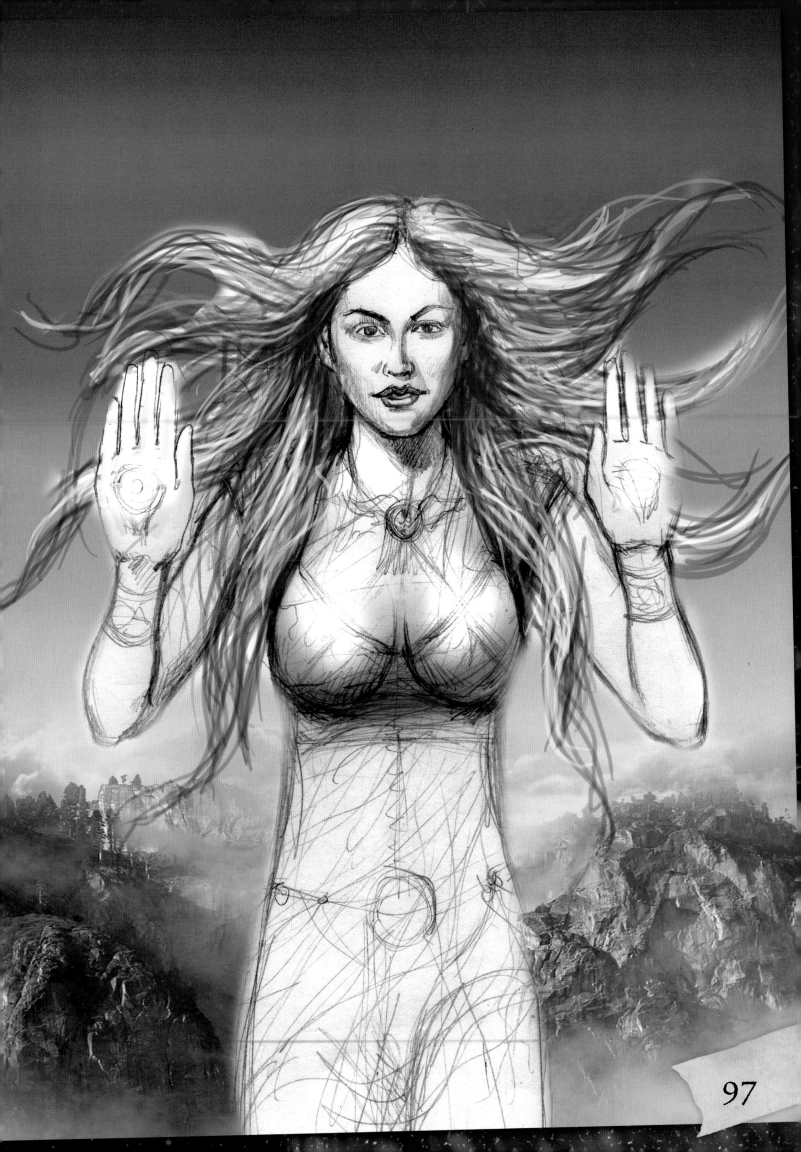

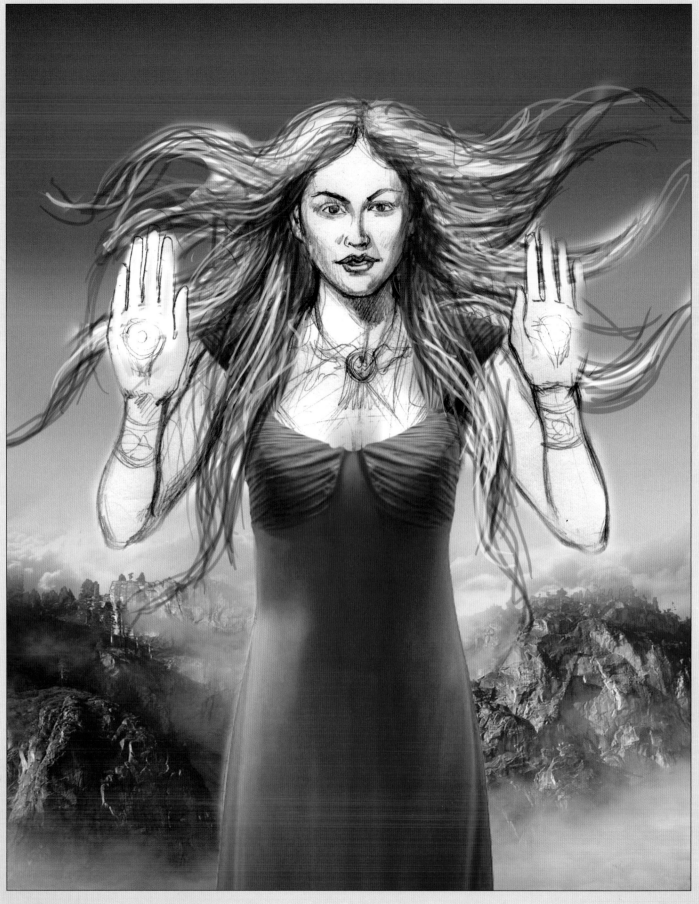

Step Three For the gown, I use a blue fabric texture and attach it to a pair of triangular shoulder straps.

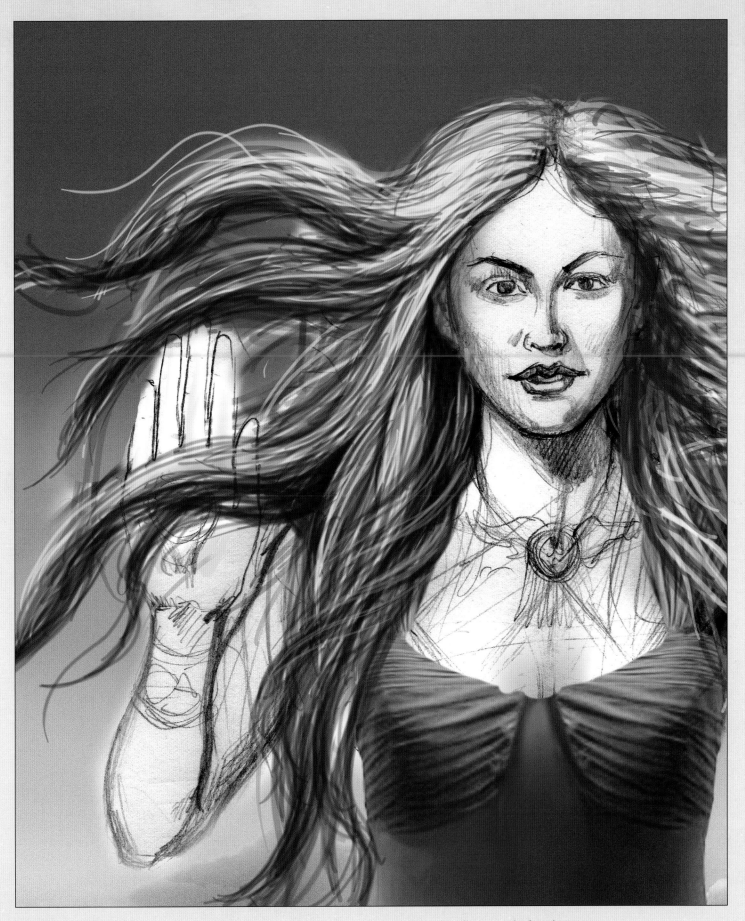

Step Four I render her hair with brown. I've already cut out her forearms on a separate layer that I'll move to the front later.

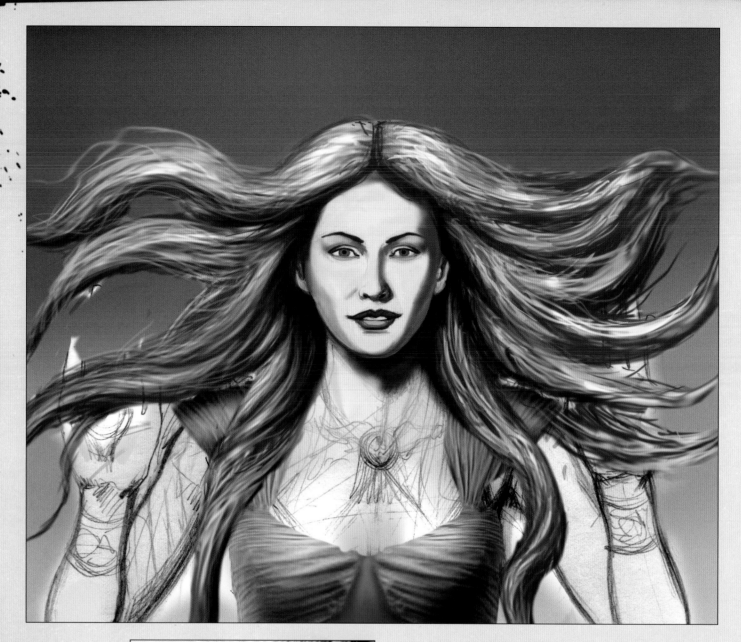

▲ Step Five I finish the other side of her hair and start working on the skin tones, which will be a cool pinkish white with magenta. The hair doesn't look like much now, but I'm just laying in the basics.

▶ Step Six I realize that I don't like the color of her hair so I decide to change it, which is easy to do in Photoshop. I simply use the Desaturate tool, which takes out all the color. Then I go up to Color Balance and change the color to a light purple. I like this much better because it contrasts with her skin more.

◀ Hair Detail Using the Smudge tool, I blend her hair, carefully following the flow of the strands. Then I go back and add sharper details, making sure the hair doesn't look blurry. I suggest you use at least three to five layers for the hair, with each layer becoming progressively sharper.

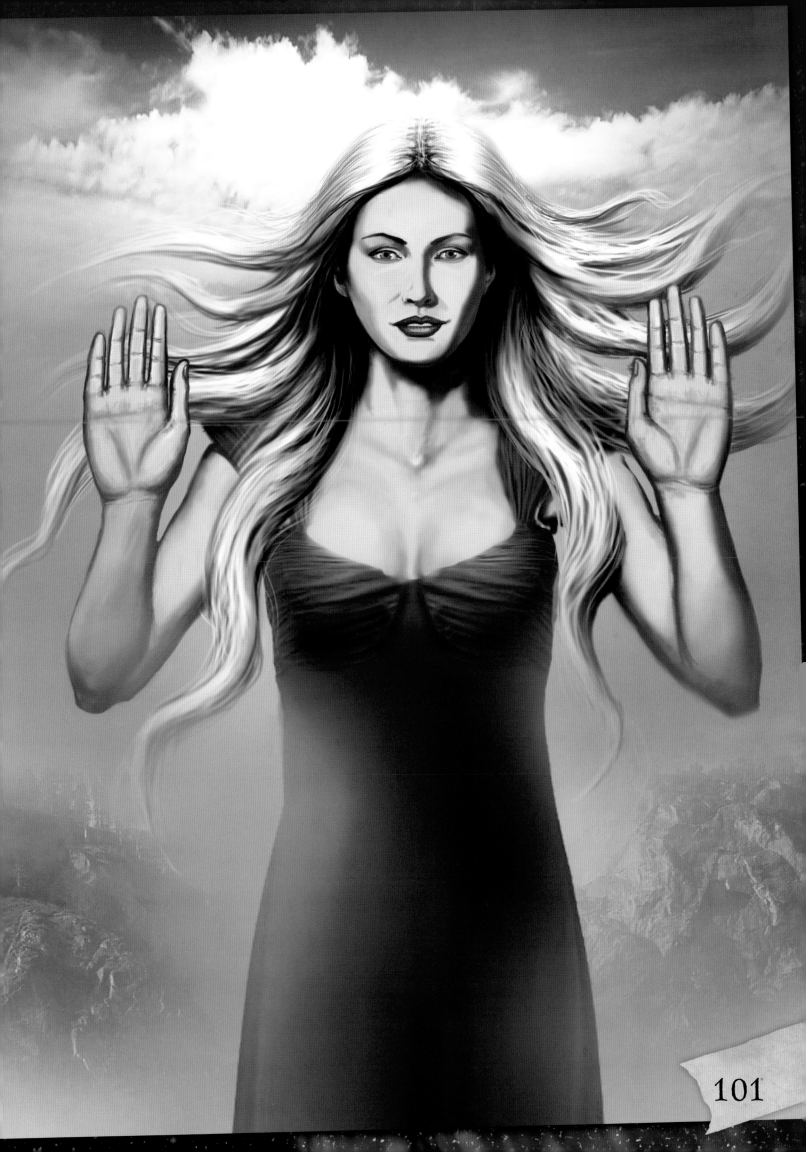

◄ Step Seven Using a vast collection of jewelry photos I've gathered over the years, I pick out the accessories I want to use. Make sure to add shadows to necklaces, bracelets, and earrings so they don't look like they're floating. I start with the bracelets, erasing the top half to make them fit her wrists and adding shadows to match those on her arm.

▼ Step Eight I add a belt, using the Warp tool to curve it to her hips.

◄ Step Nine Next I place a large broach on her dress.

Step Ten I still don't think she has enough jewelry to befit an Enchantress, so I add strands of pearls to her sides.

Step Eleven I create a headband by copying an image of a silver wing, flipping it, and placing a jewel in the middle.

▲ **Step Twelve** Keeping with the theme of mountains and wind, I add a pale shimmering sun and with an eagle flying through the sky.

▶**Step Thirteen** I airbrush several layers of blue mist over the Enchantress on separate layers, which helps her blend into the background a bit more. I also use the Dodge and Burn tools on her jewelry to make it pop. Then I make some minor adjustments to her features: I darken her eyes, shorten her nose, lighten her lips, and sculpt her jaw line. In the background I use the Dodge and Burn tools over the mountains to bring out snowy highlights.

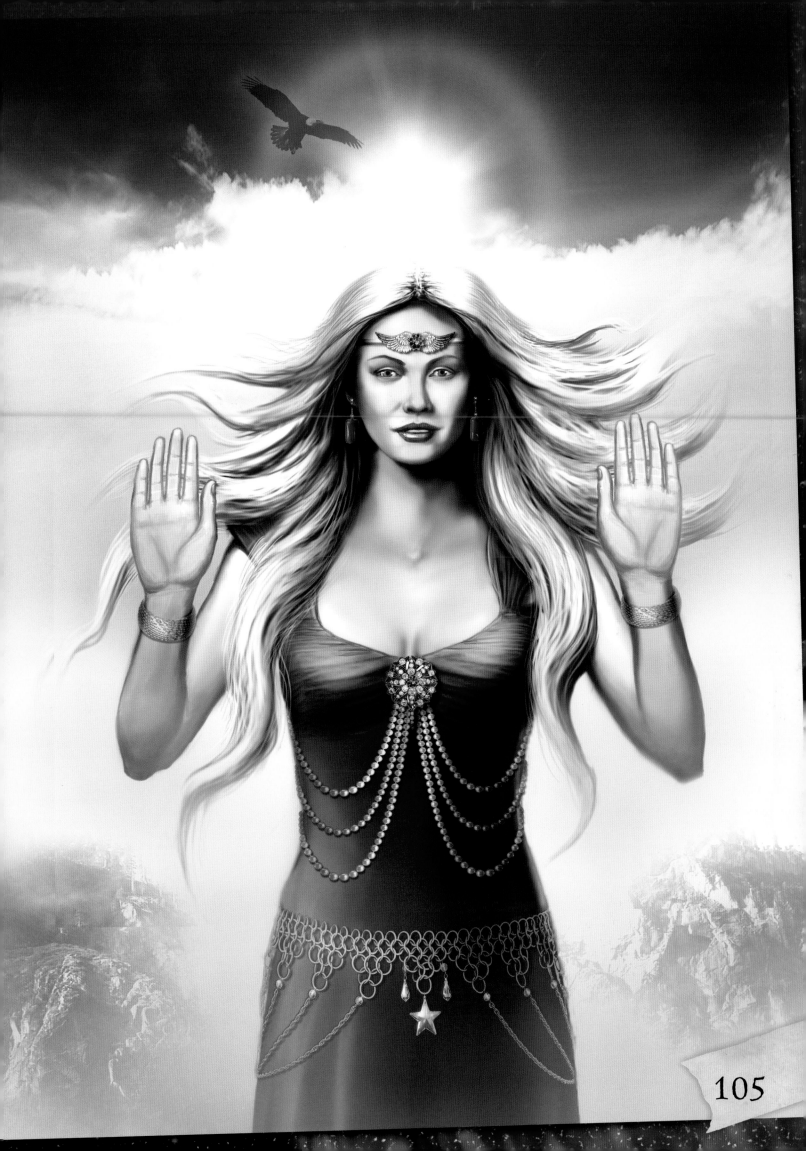

Shaman

The Shaman is a mysterious master of nature and the elements that comprise it. He can communicate with all creatures, great and small. He's a channel for the spirits of the upper and lower realms and brings healing and wisdom to the tribe he serves. He is in essence the first wizard, dating back to the era of the earliest caveman.

A seer between worlds, he walks the razor's edge between sanity and insanity. Who can witness the strange and terrible visions of the Shaman and not have his or her mind torn apart?

The Shaman's call to power can come in terrifying and unusual ways. Often he is referred to as the wounded healer, and his knowledge and power often come at a painful price. Take, for example, the Bear Shaman, who is represented in this project. Journeying in the forest in search of his power animal, he came upon a bear that blessed him with one swipe of its massive claw. Having survived this encounter, the Bear Shaman is seen as one who has died and lived again. The spirit of the bear now lives within him.

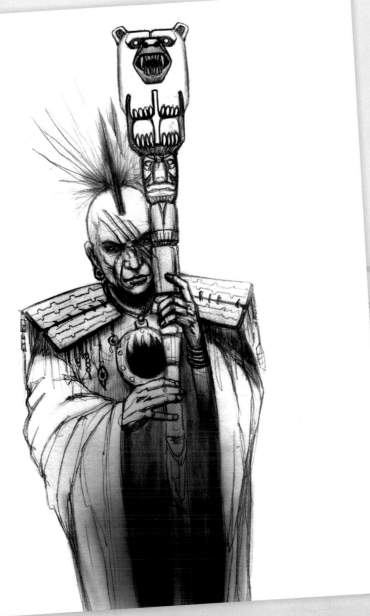

◄ **Step One** I want to create a character that is aligned in a distinctive way with an animal spirit. I also want the character to appear strong but not evil, so I give him a strong, deliberate gaze and a gigantic staff carved from wood.

▶ **Step Two** For the background, I use a stock photo of a forest. First I look at it in black and white to check out the values and composition.

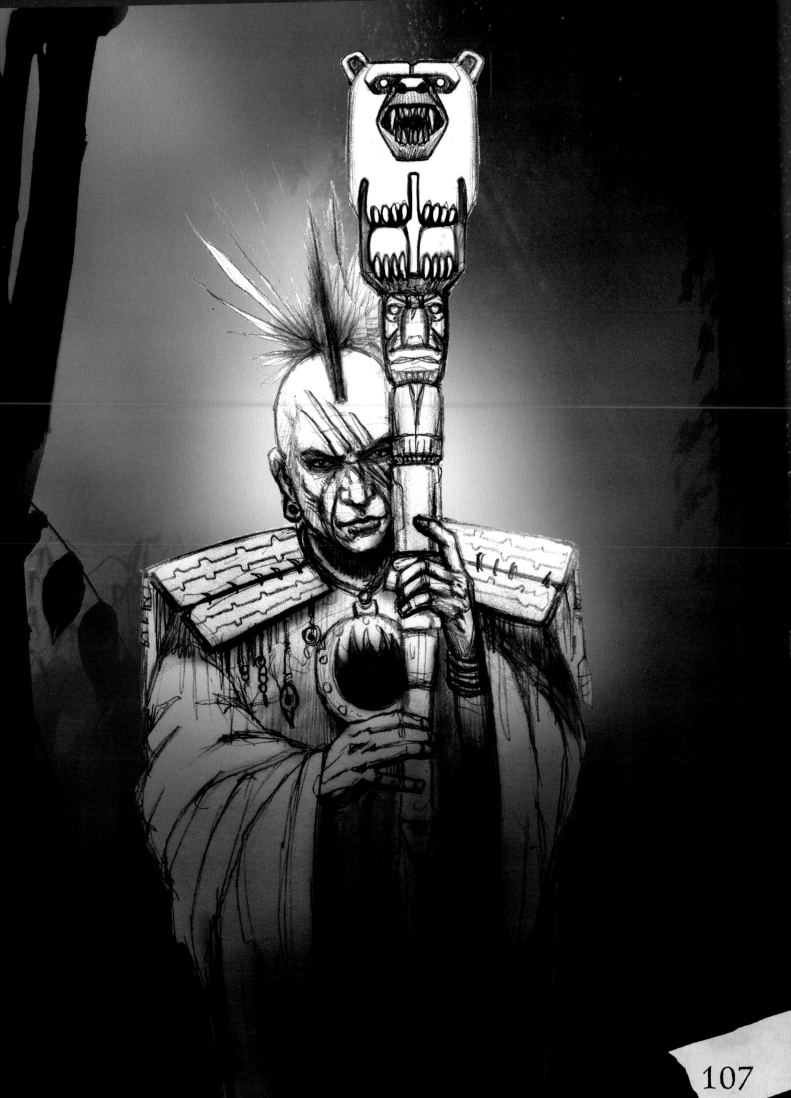

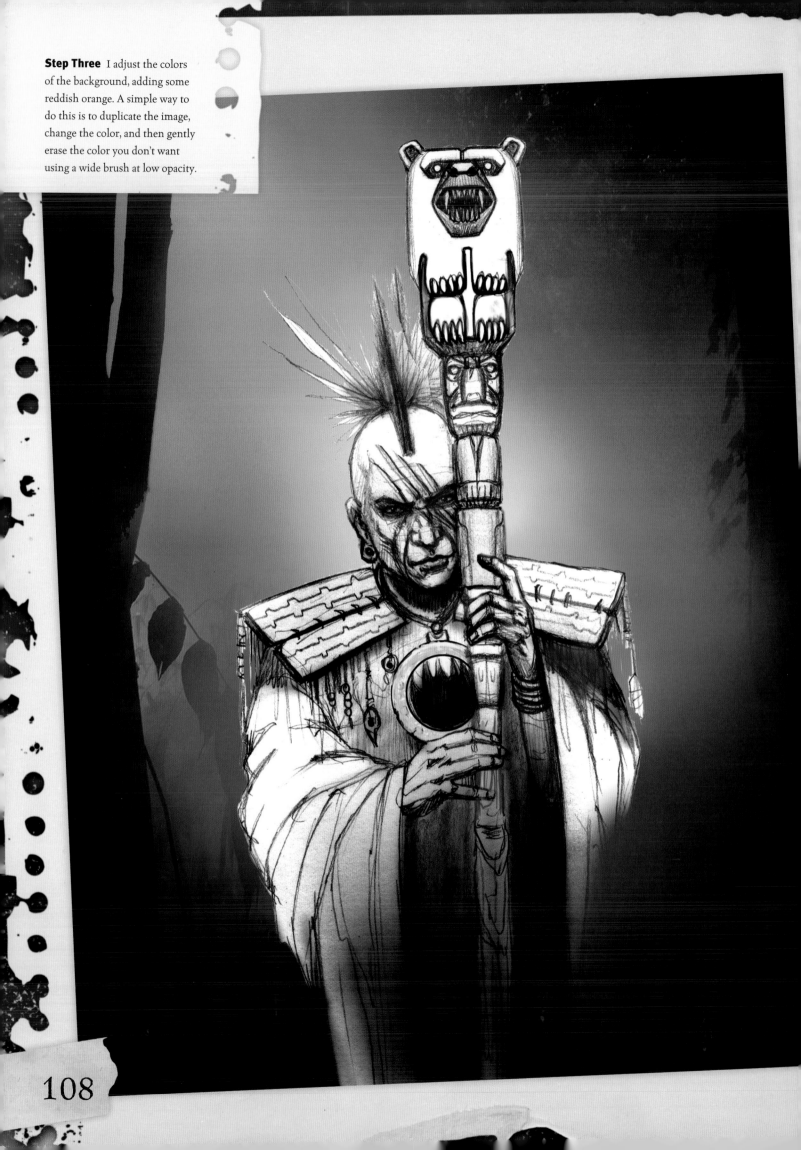

Step Three I adjust the colors of the background, adding some reddish orange. A simple way to do this is to duplicate the image, change the color, and then gently erase the color you don't want using a wide brush at low opacity.

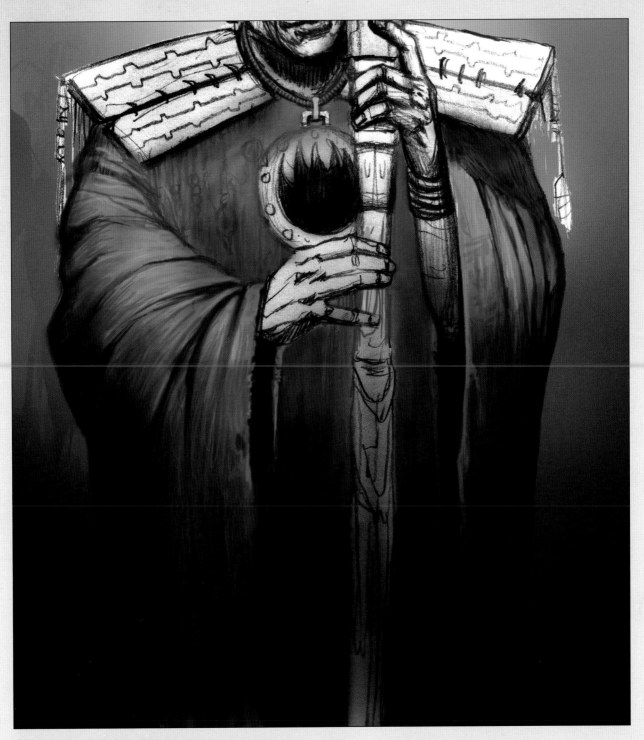

▲ Step Four Now I work on the Shaman's robe, using muted tan colors with a 15px brush. I use three different values of the tan color, from light to dark, and I make my brush larger and less opaque as I blend the edges together for smooth value transitions.

◄ Step Five Next I render the bear paw neck amulet. I want his entire outfit to look a little worn and aged; maybe parts of it were handed down from a previous Shaman since clothes and sacred objects were believed to hold spiritual power.

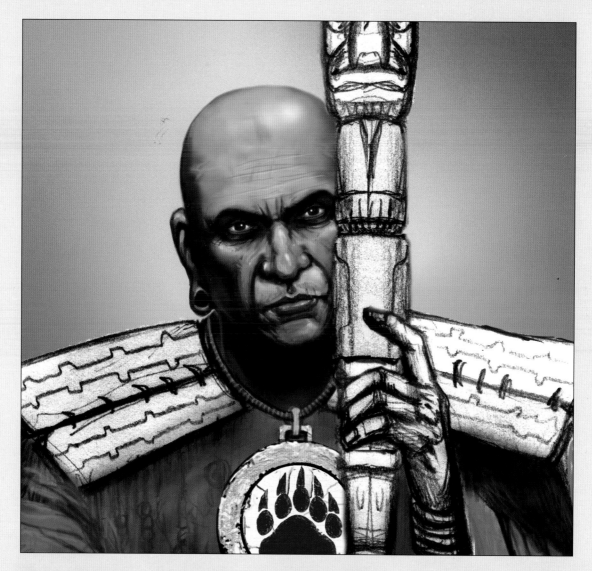

▲ Step Six When painting the Shaman's face, I keep in mind the direction of the light source, which is slightly in front of him and a little to the right. This is important because I want the staff to cast a shadow across his face and also because I want there to be dark shadows around his eyes that deepen his gaze in a subtle way. I want him to look intense but not evil. His scars will come later.

◄ Step Seven I use a combination of pheasant and eagle feathers for his headdress. I create one feather of each kind and duplicate them, making alterations in each one so they don't all look the same.

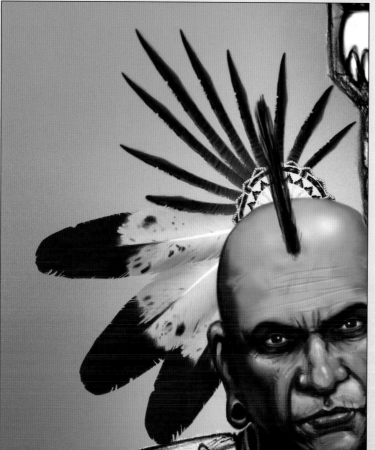

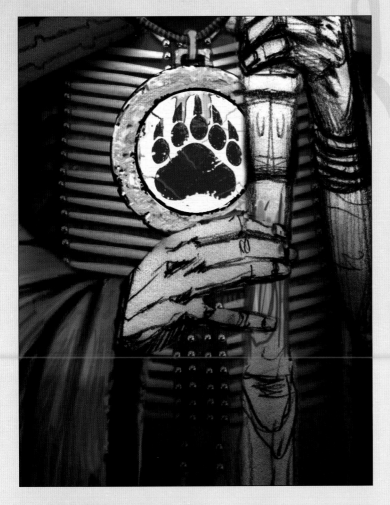

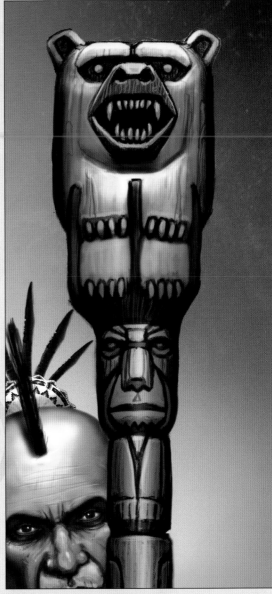

◄ **Step Eight** I decide that the Shaman needs a bone breastplate to strengthen his regalia. I place the breastplate on a layer behind the bear amulet. I make liberal use of the Burn and Dodge tools to make the breastplate conform to the shape of his chest.

▲ **Step Nine** Using the Eyedropper tool, I pick out colors from the Shaman's face to use in his hands so the skin color is consistent. I want a slightly weathered look so I accent the tendons and veins and render the skin with a slightly leathery texture.

▲ **Step Ten** Since the staff is on a separate layer, I darken it by going to the Adjustments menu, choosing Brightness/ Contrast, and taking the brightness down to -40. Using Color Balance in the same Adjustments menu, I paint the staff a dark brown. On another layer, using an up and down stroke with a middle brown value and a 25px brush, I create a grainy wood texture. Once the staff is filled in, I use the Burn and Dodge tools to add shadows.

111

◄ Step Eleven Now I render the shoulder pads using colors from the background, giving them a rough wooden texture.

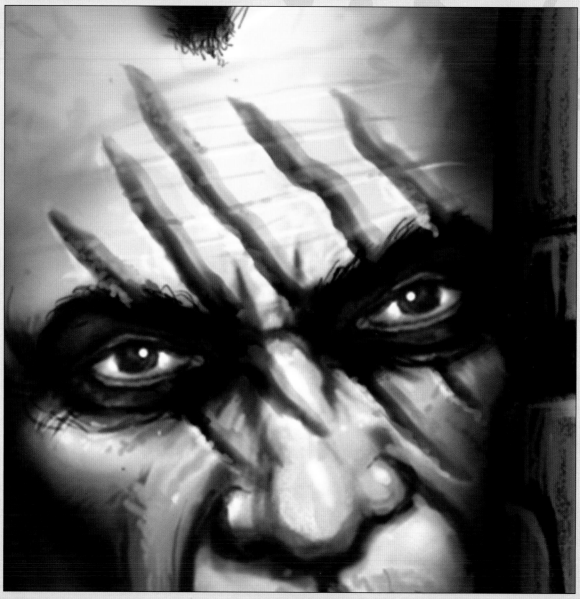

▲ Step Twelve Now I add the scars. On a separate layer, I paint five streaks of dark pink. Using the eraser I pick away at the edges, giving them a more ragged appearance. Then I add highlights.

▶ Step Thirteen Finally, I add the last shadows—those cast by the staff, his hair, and his feathers. I also deepen shadows underneath the shoulder pads a little more. I want the Shaman to pop a bit more, so using the Dodge tool and a 1,000px brush set at 30% opacity, I brighten up areas behind the Shaman's head and shoulders.

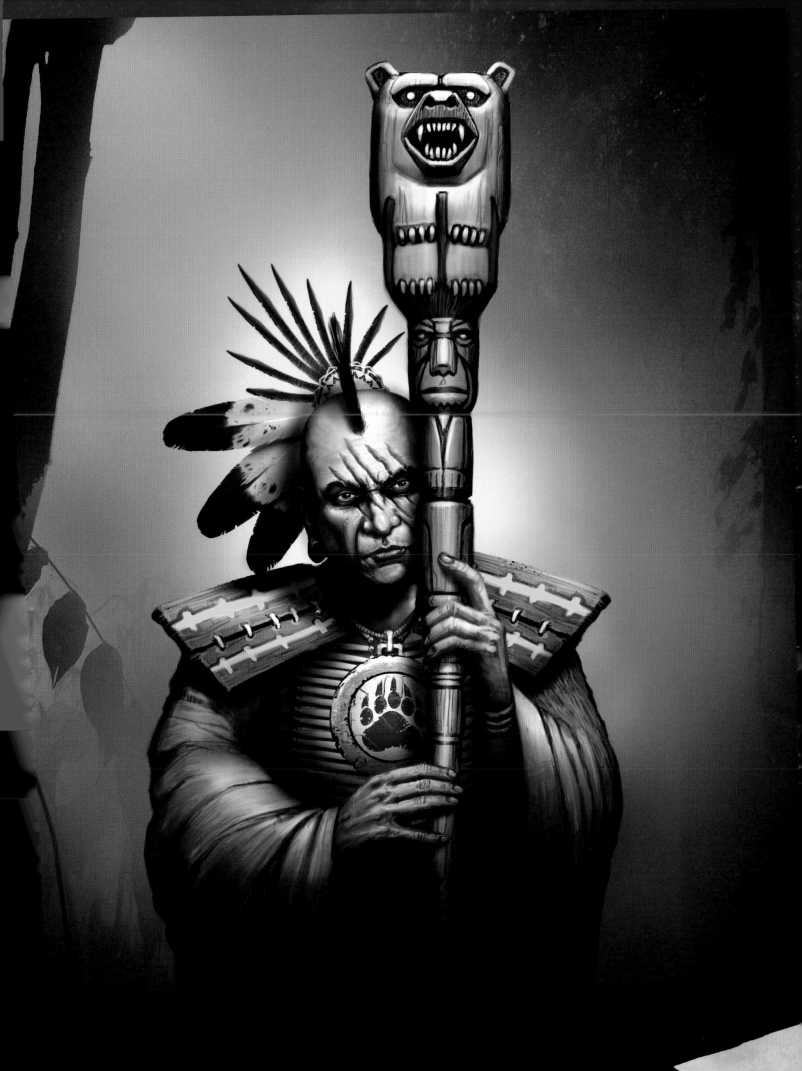

Liche King

The Liche King is one of the most feared magic users in the wizardry pantheon. He is unusually adept in the dark arts of necromancy. So adept, in fact, that he uses his powers on himself to keep death eternally at bay.

The most hideous forms of forbidden alchemy and occult ceremonies are employed by the most daring and wicked to outwit and outmaneuver the oppressive burden of their own mortality. But as we all know, no one can outrun death—not even the Liche King. Death is not mocked, least of all by wizards.

The manner in which the Liche King extends his own life is by simply stealing it from others. When he feels his own life force dwindling, he uses his powers to draw the life essence out of any living thing.

But the Liche King is also a pathetic figure. A wizard foolish enough to think he can outsmart death is approaching a sad end. He spends his last days abandoned and alone. There's no one left to torture or suck dry. With no one left to do his bidding, he sits slumped on his crumbling throne, waiting for his final terrifying appointment with death. His once formidable powers gone, lost in the evil memories of his past glories, he thinks back to a time when his name was feared and spoken with dread across the land.

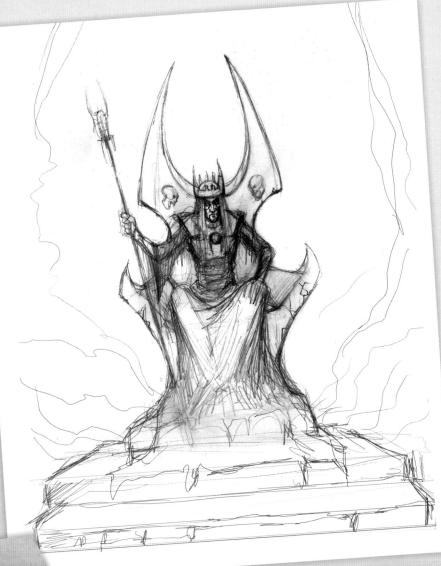

◀ **Step One** I want to create something different this time and stay away from the standard depiction of the Liche King. In my version he's long past his prime. Think of King Lear as a Liche King with his kingdom in a state of decay and desolation; this is not a happy place.

▶ **Step Two** As usual, the first thing I do is cut up the rough and place the different elements on separate layers. The first layer is the background, the second the stairs, the third the throne, and the fourth the Liche King. He will, in the end, possess the most layers, as his face, hair, crown, and staff will each have its own layer. I choose a palette with warm colors descending to a darker bottom, which will partly shroud the stairs.

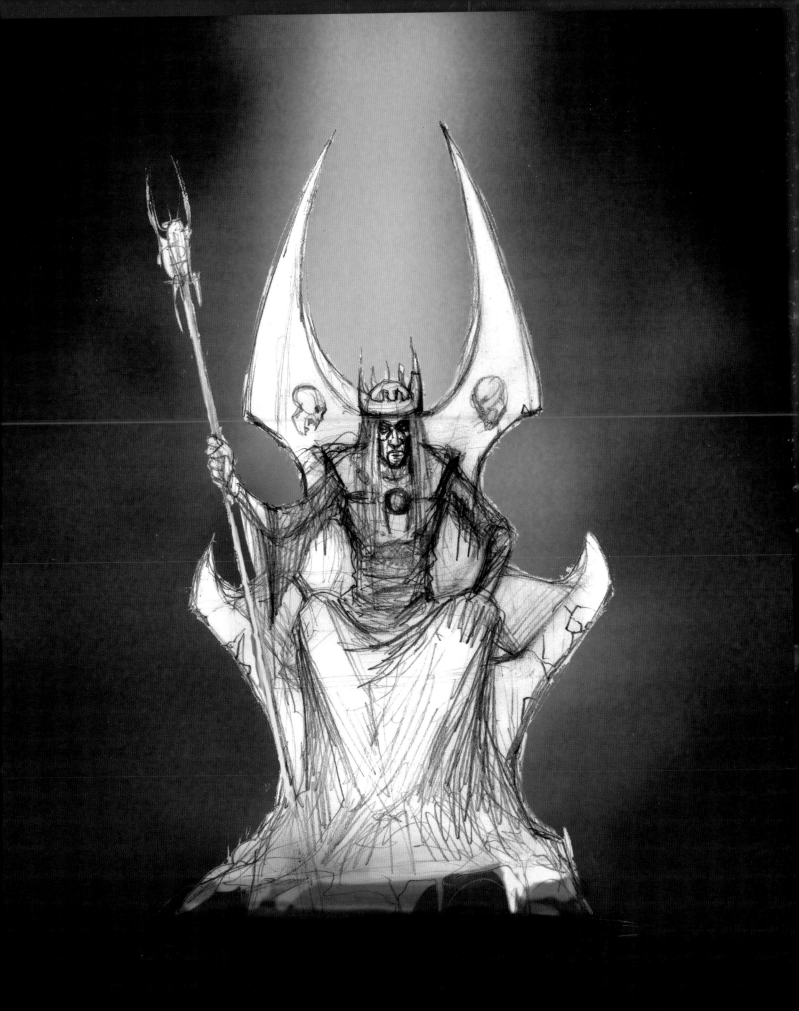

▲ Step Three Using a combination of violet and blue, I work on the steps. I add cracks and shadows as I go, darkening the steps toward the edges. Only the middle will be bright and well defined.

▶ Step Four I design the throne with sweeping curves that direct your eye toward the Liche King's face. I also start on a theme of rotting stone and bone textures, which I will eventually use in the crown.

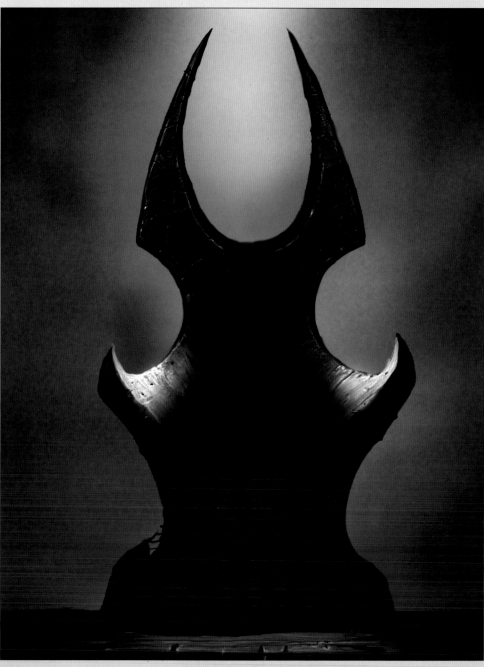

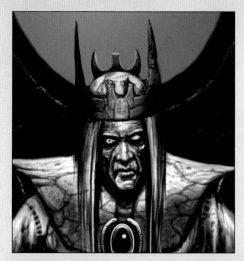

◄ Step Five Now I work on the face, using steely blues to accent his coldness. I make one eye blank and dull and the other a pinpoint of pure hate. I add deep shadows around the eyes to accentuate his stare even more. Next I render the hair using a 5px brush. I use the Smudge tool to smooth out the ends and blend the separate strands together slightly.

▼ Step Six His clothes come next. I give his shoulder pads a bone texture to go along with his crown, and I add a black jewel to represent his heart.

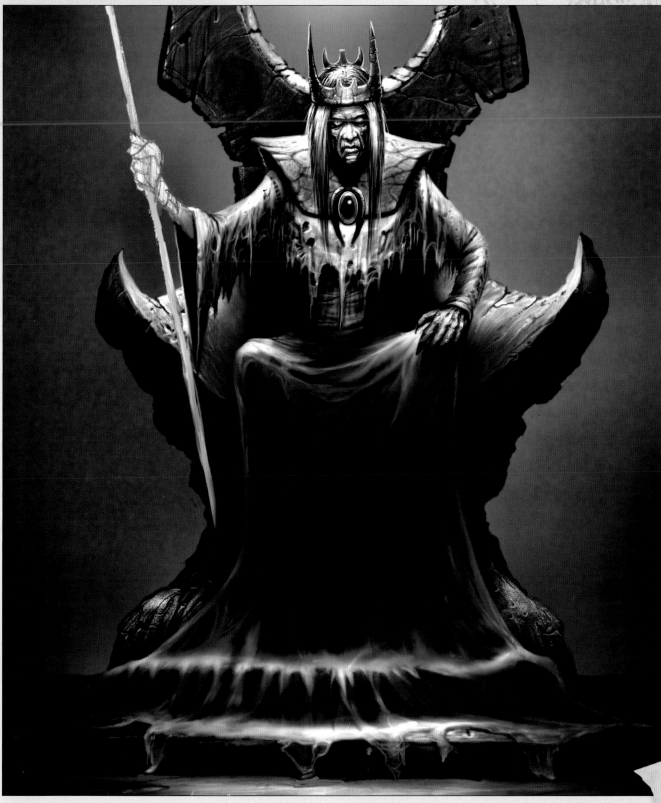

117

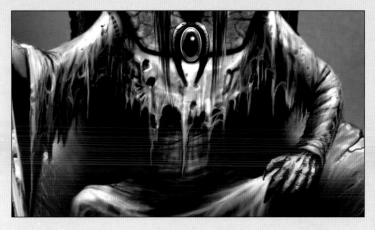

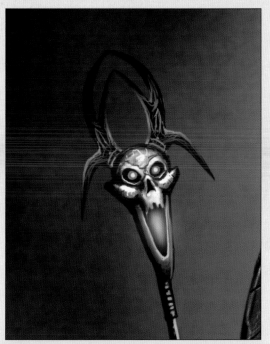

▲ Clothing Detail His once-royal robes now hang in dirty rags from his bony frame. His robe almost swallows him up since he's become so diminished and shrunken.

▶ Step Seven Because the staff was once used to suck the life energies out of his victims, I design it with a gaping mouth. Next I paint the Liche King's hand and forearm.

Step Eight I add bone and skull fragments on the steps to represent the remains of his last victims.

Step Nine I add laughing skulls on each side of his throne. It's almost as if death is mocking him now.

▶ Step Ten I add an overlay of mist to soften the edges of the stairs even more and push back the top of the throne. I add highlights to the throne and take out some chunks, making it look more decrepit. Almost all the highlights at this final stage are done with the Dodge and Burn tools. Remember not to overuse these tools, though, as you could end up sucking the life out of your painting.

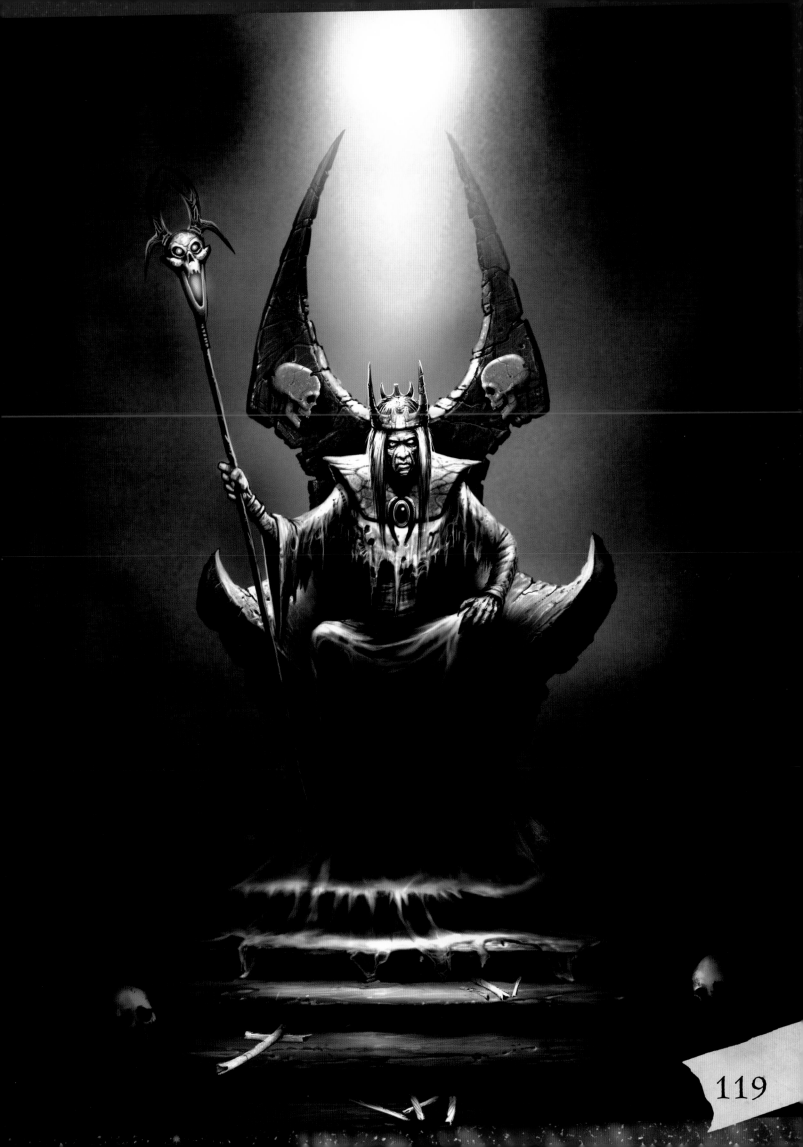

Wizard Battle

For this final project, I decide to do what's known as a "speed painting," or one that is completed in a few hours using broad, impressionistic strokes. The purpose here is to work quickly. This technique is used mainly in concept art for video games and movies, where getting a series of paintings done quickly is important. More detailed renderings will come later, after the art direction has been decided. The key here is simply to paint and not to over-render. Too much detail will actually ruin the painting, so keep it simple and strong. Remember to always put each new element on a separate layer. It's easy to forget once you get caught up in the process.

This project is a representation of a wizard war or the eternal battle between good and evil. I don't sketch a rough or any thumbnails; I just start painting. All I know at this point is that I want to include flashes of lightning.

◄ Step One I usually like to start off with a dark, texturized background. I don't like to paint on smooth, bland surfaces.

► Step Two Staring at the background, I suddenly imagine a black spire rising up to the sky. For the majority of this painting (except near the end), I'll be using the pencil tool with the Chalk brush preset, with the opacity set from 80% to 100%. I suggest trying out a variety of textured brushes to see what works for you.

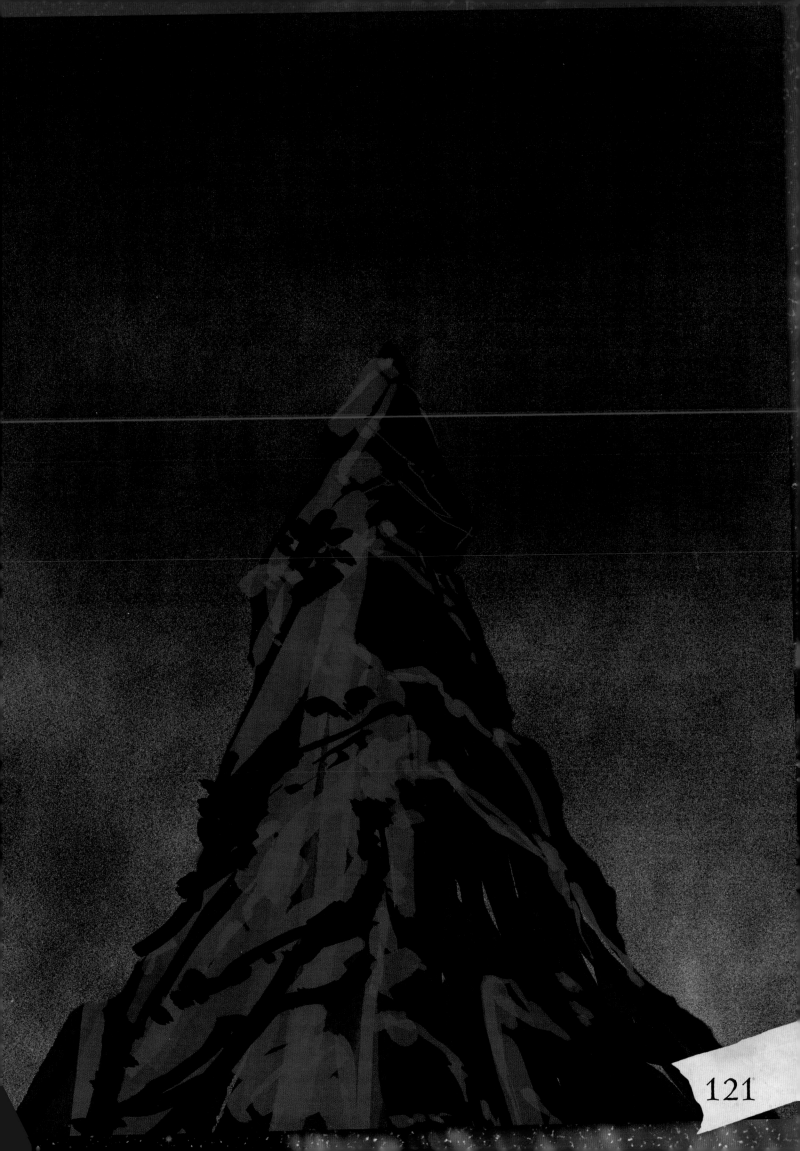

Step Three Now I imagine a dark sorcerer flying out of the sky and landing on the tip of the spire.

Step Four I suddenly realize that the sorcerer has brought some nasty creatures with him. I can only see dark masses at this point, but I know they are going to turn into something. I'm just working on basic composition at this point.

122

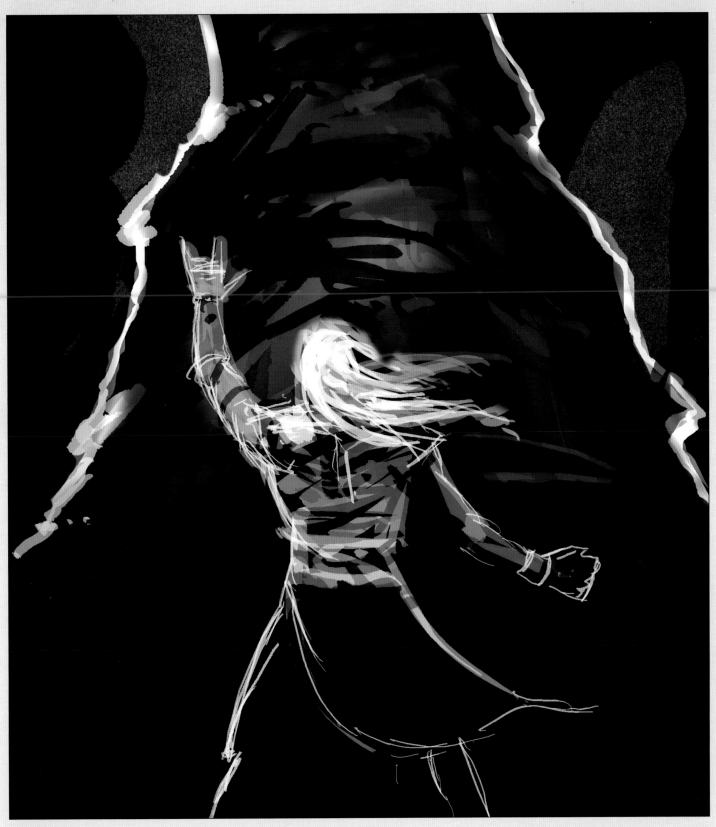

Step Five Our hero finally arrives: a wizard standing in for the forces of light. He gazes up at the dark sorcerer, ready for battle. I give him a strong stance: His left arm is raised to cast a magical spell, and his right hand holds his staff.

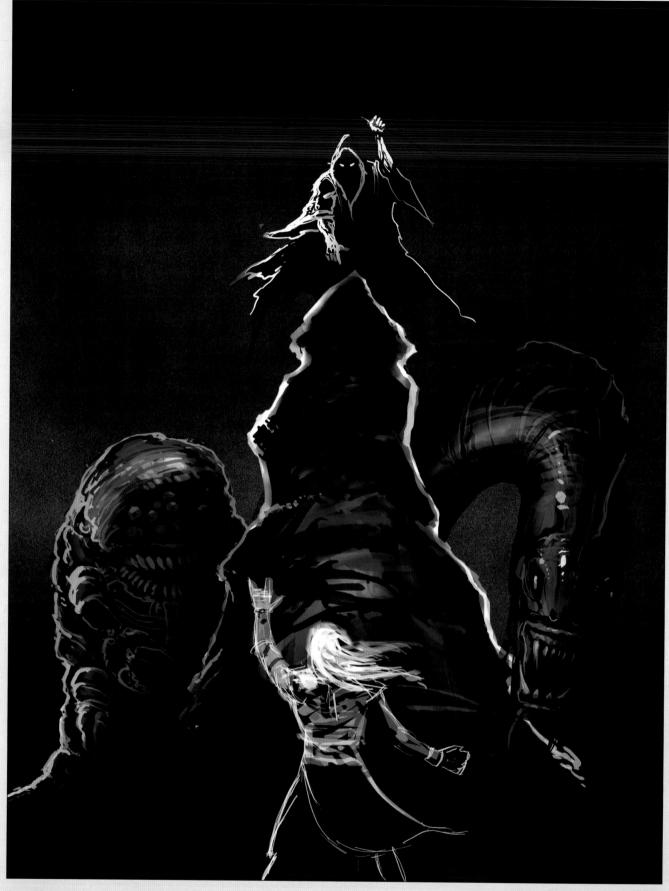

Step Six Now the monsters come into view. One is a slimy caterpillar-like creature with a wide, toothy mouth. The other is an eel-like serpent. They need a few more details, but we'll come back to them later.

▶ **Step Seven** I add details to the wizard, including touches of gold on his outfit. I also add foreground rocks on either side.

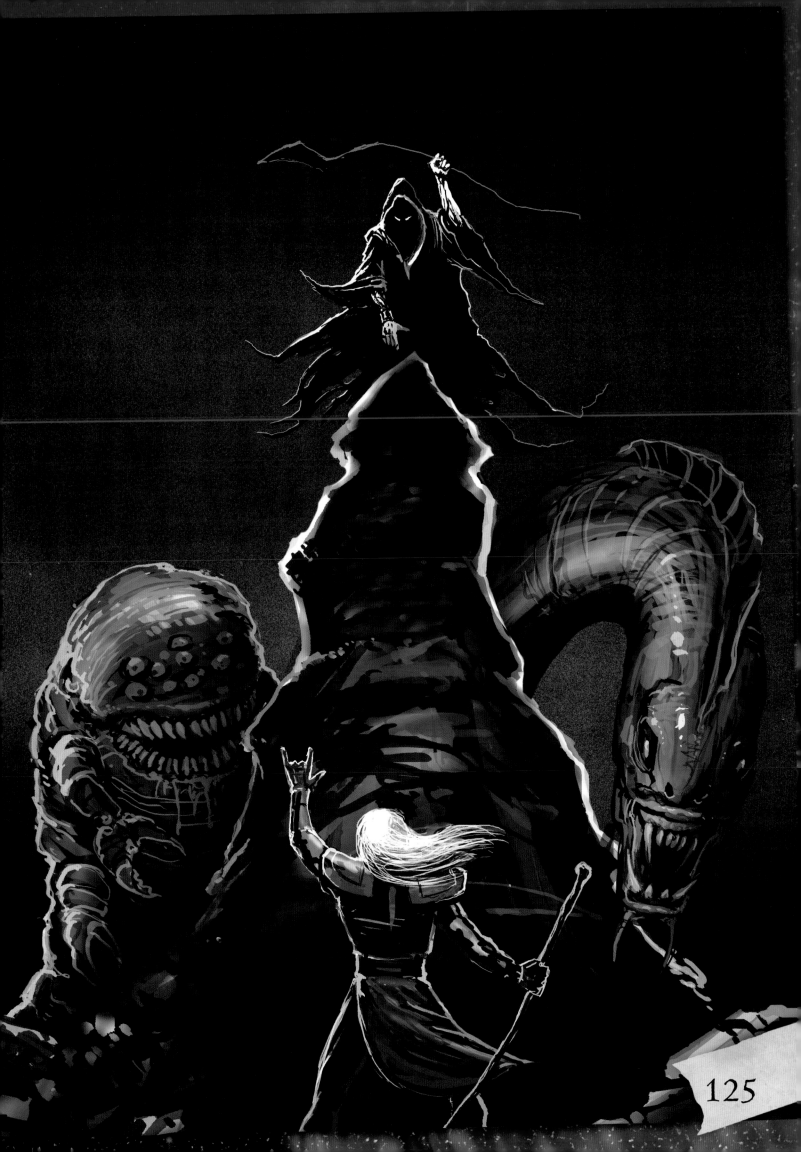

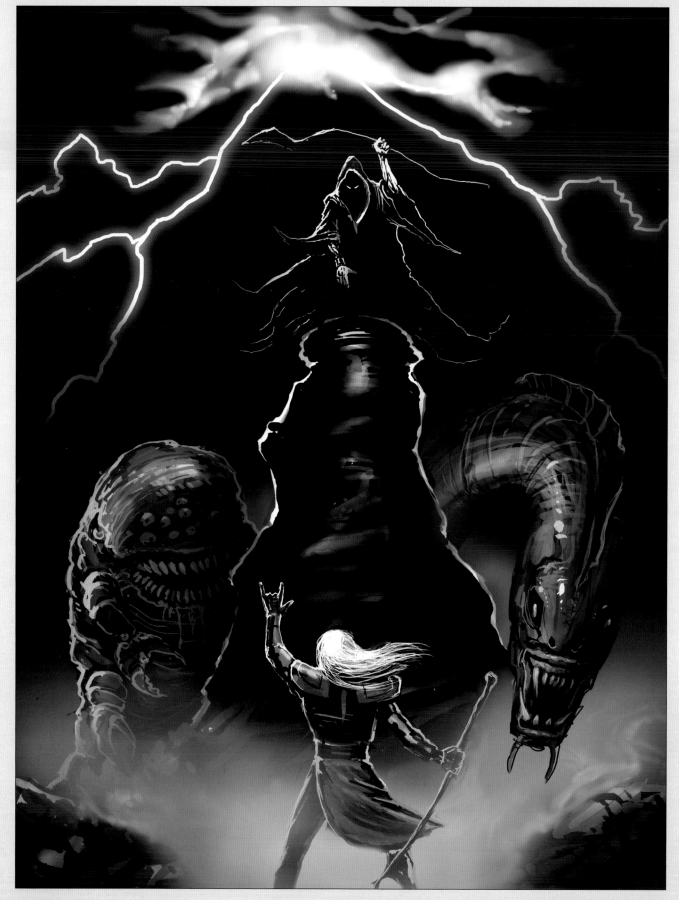

Step Eight Now it's time to bring down the lightning. After I draw the lightning, I add a slight glow around it. Then I add clouds that have been illuminated by the lightning. Using the Airbrush tool, I spray a layer of pale mist at the foot of the spire. Then I add a bit of color to the monsters using the Color Balance tool. In most speed paintings, the colors are muted. The more colorful paintings are, the more complicated they are.

▶ **Step Nine** Now I add the final flourishes using the Dodge and Burn tools. Next I use the Highlight tool to brighten up the mist. I also brighten the light above the sorcerer. I add a circle of light around the wizard's hand, while the evil sorcerer has jagged bolts of light coming from his finger. Next I give each figure a soft glow effect, and I darken the spire and refine the edge lighting. Finally, I add more rocks in the background to give it more depth. In total, the painting took about three hours of intense work, with a 15-minute break in the middle.

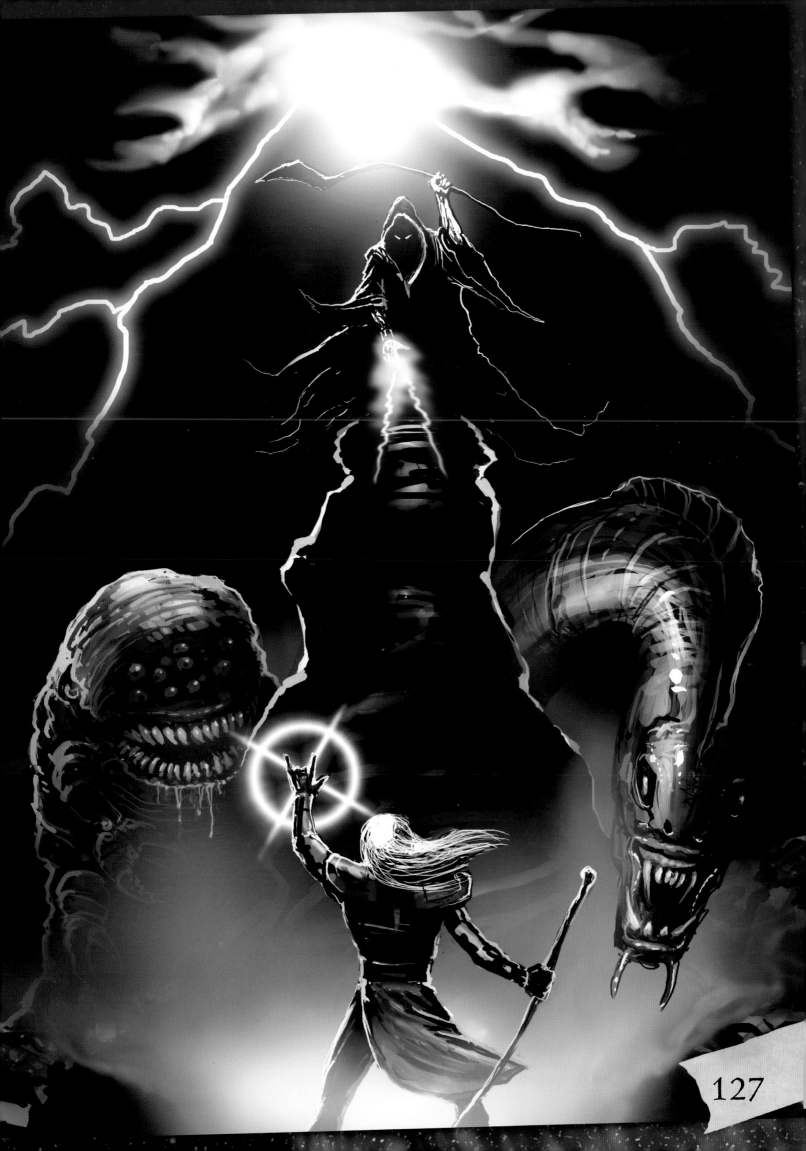

Closing Words

When my students get ready to go off and find their own way, I think about what bits of wisdom I would like to pass on to them. First and foremost I tell them to be grateful wherever they are in the long journey of their development as artists. All good and kind wizards know how to live in the moment and not for the moment. Appreciate your friends, family, and teachers right now, and let them know that you do.

I say this because it's the one thing I know I never did enough of back when I was starting out. If there's one thing I've learned in the intervening years it's that you can never say thank you enough.

Personal success as an artist is dependent on one single factor: showing up. Something magical happens when you've committed yourself completely to the artistic tasks at hand. When you do this, something extraordinary happens. The Muse, along with her bastion of inspirational helpers, will suddenly appear to support you until the work is finished.

I've noticed that the best artists and writers I've known, from Charles Vess to Clive Barker, all have certain traits in common. One of the main ones is generosity of spirit and a natural desire to help and guide other artists. There's a sense that they've tapped into something higher than themselves. They know they're just instruments that inspiration has chosen to work through. They're confident in their abilities but also humble.

Healthy competition between artists can be fun, but always revel in the success of others. Arrogance is not a flattering trait. Be good to people on the way up because there's a good chance you'll see them on the way down.

Search out your fellow artists of like mind and work on projects together. So much of today's art is done collaboratively. A collection of inspired minds is much more powerful than just one.

A wizard is in love with life and the power of imagination. And what is an artist but a wizard with a pencil, brush, or computer? With our own special kind of magic we open up the hidden doors of wonder and show people things that have never been seen before. Be thankful to possess such a gift.